Paint This with Jerry Yarnell®

Wildlife Scenes in Acrylic

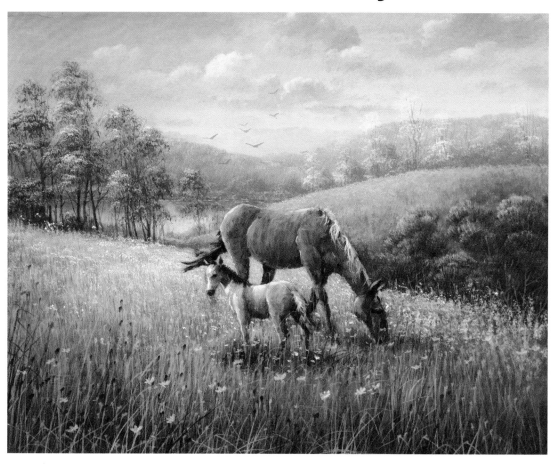

Paint This with Jerry Yarnell®
Wildlife Scenes in Acrylic

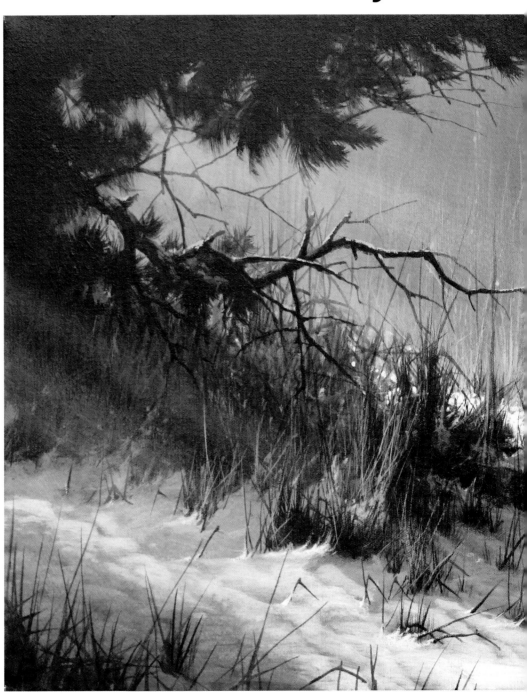

Tracking, Acrylic on stretched canvas, 24" × 36" (61cm × 91cm)

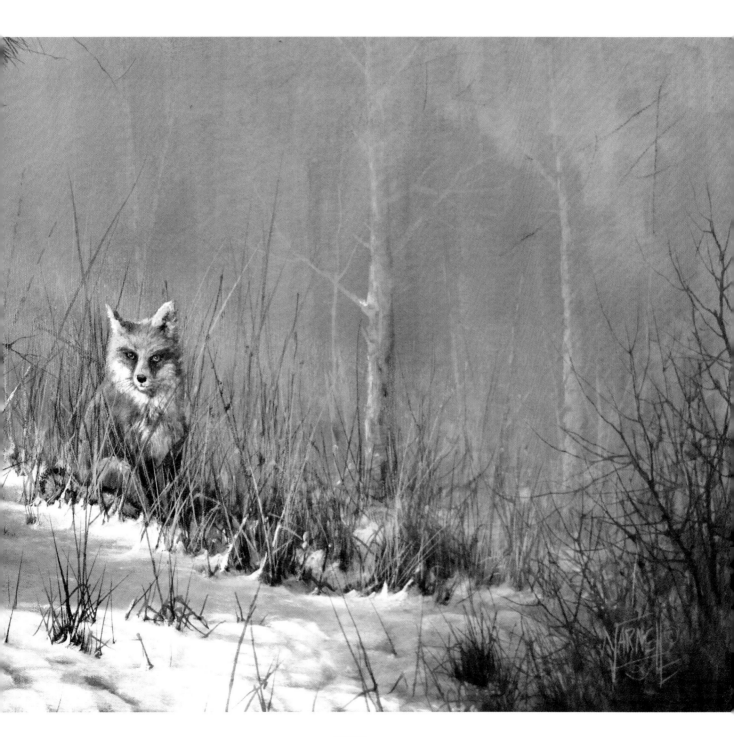

NORTH LIGHT BOOKS

CINCINNATI, OHIO

artistsnetwork.com

Contents

What You Need

SURFACE
stretched canvas

ACRYLIC PIGMENTS
Alizarin Crimson, Burnt Sienna, Burnt Umber, Cadmium Orange, Cadmium Red Deep, Cadmium Red Light, Cadmium Yellow Light, Dioxazine Purple, Hooker's Green, Naphthol Crimson, Phthalo Green, Turquoise Deep, Ultramarine Blue, Vivid Lime Green

BRUSHES
- 2" (51mm) hake
- nos. 2, 4, 6, 10 and 12 bristle flats
- nos. 2, 4, 6 and 10 Dynasty brushes
- no. 4 sable flat
- no. 4 sable round
- no. 4 sable script

OTHER
- compass or circle template
- fine-grit sandpaper
- medium or firm toothbrush
- paper towels
- soft vine charcoal
- water mister bottle
- white Conté pencil
- white gesso

Deer in the Sunlight
Acrylic on stretched canvas
24" × 18" (61cm × 46cm)

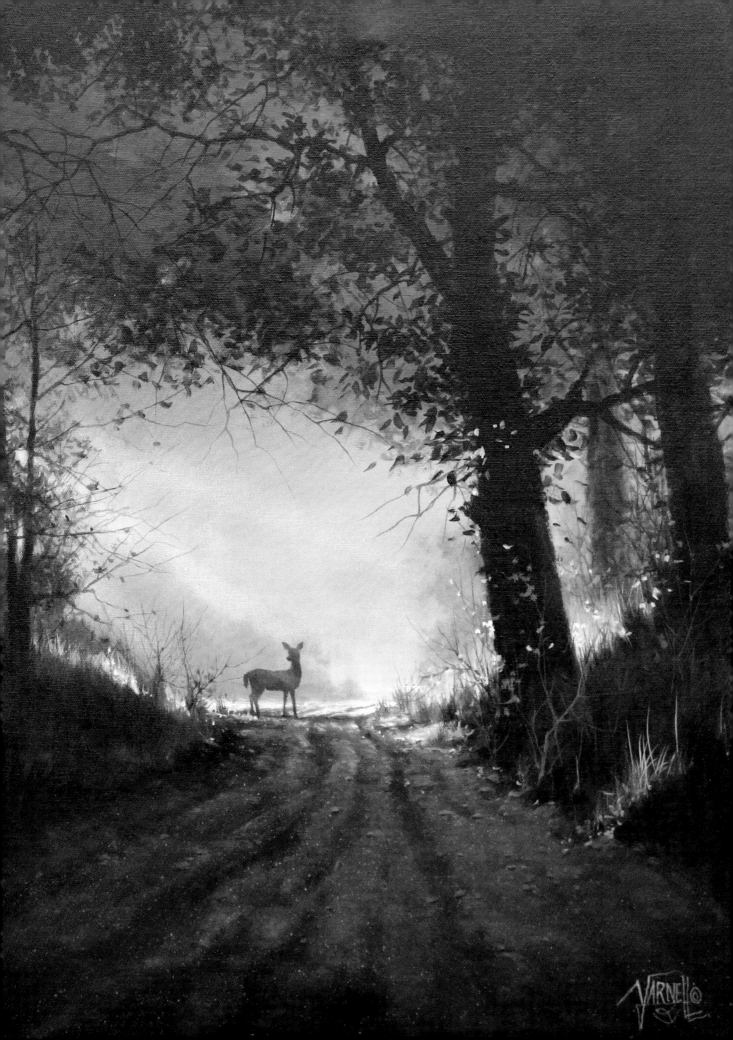

Introduction

Successfully creating a beautiful landscape painting is one of the most rewarding experiences an artist can have. Perhaps this is why landscapes are among the most painted subjects in the world. My own experience, both as a professional artist and as a teacher of thousands, has taught me that about 75 percent of students prefer painting some form of a landscape. No matter what style, technique or medium you use, it seems you cannot go wrong painting a beautiful landscape—especially if you are in the early learning stages of your art career.

In addition to a strong composition and interesting subject matter, a good landscape uses a vast array of values, colors, light sources, shadows, textures and brush techniques. In this book, we will cover each of these key elements of painting. We will also explore the process for painting birds and animals into landscapes so that you can add even more interesting elements to your painting compositions.

Regardless of whether you are a beginner, intermediate or advanced painter, this book will provide multiple opportunities for you to improve your artistic abilities and take full advantage of your artistic license. So grab your palette and brushes, and let's get started!

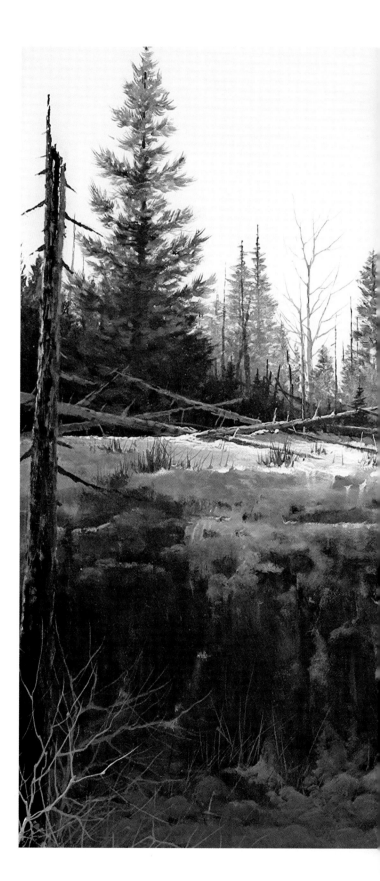

Lone Wolf
Acrylic on stretched canvas
24" × 36" (61cm × 91cm)

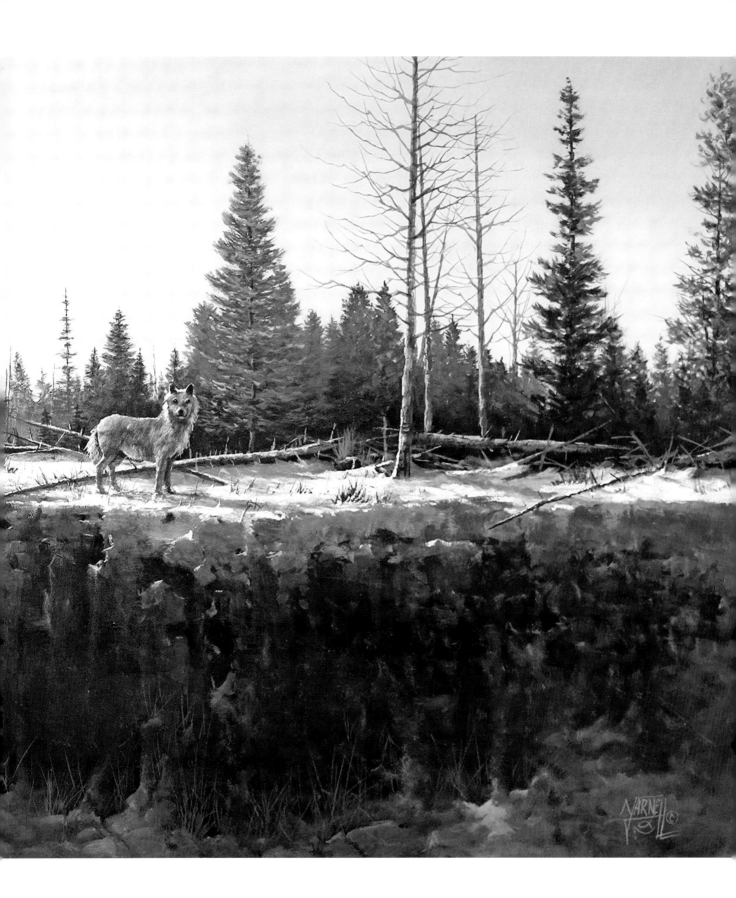

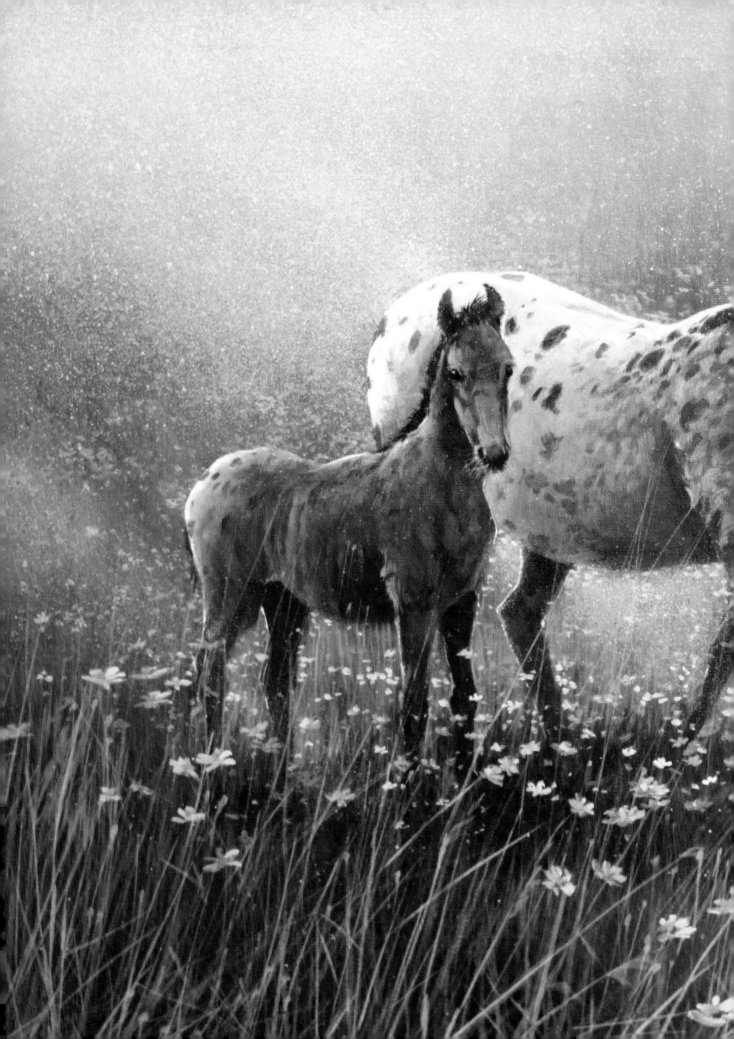

Materials

As the old saying goes: The quality of your project is only as good as the quality of the products you use. As a fine artist, I insist on using the highest quality products that meet archival standards (museum grade). All of the tools and materials covered in this book are professional grade. These supplies can be found in most art stores, except for the brushes. The brushes I use are my own design and can only be purchased from the Yarnell School of Fine Art (yarnellschool.com) or from a Yarnell Certified instructor.

When choosing art supplies, try to purchase professional-grade products when possible. If you are a beginner and still developing your painting skills, or if you have a limited budget to work with, student-grade materials are the next best option. I guarantee that the quality of the materials you use will correlate directly to the ease of your experience learning to paint, producing better art and having a product that will stand the test of time.

Appaloosas at Morn
Acrylic on stretched canvas
16" × 20" (41cm × 51cm)

Brushes

There is a wide variety of types and sizes of brushes available for artists. To make things simple, the descriptions below cover only those brushes you'll need to complete the paintings in this book.

2" (51MM) HAKE (GOAT HAIR)

Use this brush with acrylics and watercolors only. It is made of goat hair, one of the finest hairs used in paint brushes, so it has a tendency to shed. However, this brush creates beautiful, soft blends over large areas, like skies and water. It also creates mottled backgrounds, such as those used in still life and wildlife paintings.

1½" (30MM) BRISTLE FLAT

All of the paintings in this book were done in acrylic, but the techniques work great for oils as well. If you prefer to work with oils, substitute this brush for the hake when painting glazes, water, skies and other large areas. (Hake brush hairs are too fine for oils.)

NOS. 2, 4, 6, 10 AND 12 BRISTLE FLATS

Thicker-bodied paints like acrylics and oils work best with these brushes. Their coarse bristles are great for brush techniques such as scrubbing and dabbing. They also work well for underpainting backgrounds and adding texture. These are not brushes for fine details.

NOS. 2, 4, 6 AND 10 DYNASTY (CHISEL EDGE)

These well-balanced brushes are made of nylon. When wet, they hold a very sharp chisel edge. This makes them perfect for clean-edged, structured subjects like fence posts, tree trunks,

wooden objects and wood grain. Because of their extreme flexibility, they work well for creating tall weeds, individual leaves and leaf patterns. They make beautiful flower petals for broad-petaled flowers, too.

NO. 4 SABLE FLAT AND NO. 4 SABLE ROUND

These small brushes are perfect for areas of fine detail and for blending soft edges. They work particularly well for close-up details of birds, animals and small foliage patterns. These are fairly delicate brushes, so be careful not to scrub with them or abuse them in any way, or the hairs will bend and separate, making them unusable.

NO. 4 SABLE SCRIPT

Often referred to as a liner brush, this can be used with any medium, as long as the paint is thinned down to an ink-like consistency. It works great for tree limbs, weeds and any other fine-line work.

Jerry Yarnell Signature Acrylic Brush Set (8)

Most types and sizes of brushes can be purchased in art stores, with several brands available to choose from. However, Jerry Yarnell Signature Brushes and brush sets can only be purchased at a Yarnell Certified instructor's workshop or at yarnellschool.com. Sales of brushes appearing to be Jerry Yarnell Signature Brushes via any other source have not been authorized by Jerry Yarnell or the Yarnell Studio & School of Fine Art, LLC.

A: no. 4 sable round; B: no. 6 bristle flat; C: no. 4 bristle flat; D: 2" (51mm) hake; E: no. 10 bristle flat; F: no. 2 bristle; G: no. 4 sable script; H: no. 4 sable flat

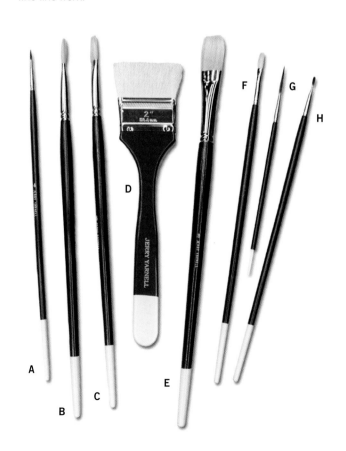

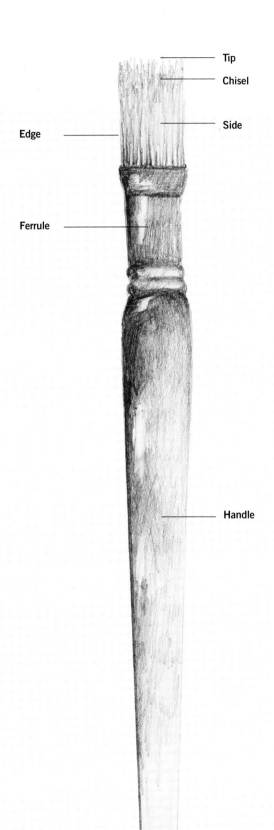

Tip

Chisel

Side

Edge

Ferrule

Handle

Anatomy of a Brush

- **Tip:** The very end of the bristles. Used for tapping to create delicate effects.
- **Chisel:** The area just below the tip. Often tapered to help form a narrow tip.
- **Side:** The larger flat area. Mostly used to scrub or for blending larger areas.
- **Edge:** The narrow side of the bristles. Also used for scrubbing and blending.
- **Ferrule:** A hollow metal sleeve that the bristles are inserted into. It is usually glued to hold the bristles in place. It can be round or flat.
- **Handle:** The handle is normally wood or plastic and is inserted into the base of the ferrule. Usually it is wider at the base of the ferrule, then tapers as it gets longer to help with balance and grip.

Brush Care

There is not a day that goes by that I do not receive questions from students concerning the care and condition of brushes. The two most common questions are: "Why do brushes shed?" and, "Why does paint peel off the handle?" Both answers have to do with water.

BRUSH SHEDDING
The first thing you must understand is that *all* brushes shed. However, some brushes will shed more than others, for various reasons.

- Cheap, low-quality brushes are more likely to shed than high-quality, expensive brushes. So, always buy the highest quality brushes you can afford.
- Brushes with very fine hairs are more likely to shed. For example, a hake brush is made of goat hair, so it will be more likely to shed than a brush with thick, coarse hair.
- Too much long-term water saturation will eventually cause a brush to shed. Under normal use, this shedding is minimal. However, if you leave your brush lying in a water basin as you paint, the constant exposure to the water will cause the glue in the metal ferrule to soften over time, and the brush will begin to shed. Instead of leaving your brushes sitting in water, wet the bristles and lay them aside.

Brush shedding may be slightly annoying, but it's perfectly OK to leave the hairs in place as long as they are not extremely noticeable—especially if they are embedded in areas like rocks, grass and trees. The next time you are at a museum or gallery, take a close look and you will see some hairs and other small pieces of debris embedded here and there. Most artists choose to leave stray hairs in place, as opposed to trying to remove them and risk messing something up.

If you are a beginning artist and are not used to brush shedding, you might find yourself spending a lot of time trying to remove every hair. Granted, there will be times when a hair needs to be removed because it's just plain distracting, but in general, removing hairs is a personal choice. Most brush hairs will not be an issue and you should not feel obligated to remove them. However, if they bug you, take them out.

If you really don't want any hairs in your painting, you can pick them out with your fingernail or a palette knife as you paint. Another option is to let the painting dry thoroughly, then lightly sand the hair off with a small piece of sandpaper. Usually, it comes off easily.

PEELING PAINT
Paint peeling off the handle of the brush is another common problem. Once again, this is all the result of continuous exposure to water. Never let the brush handle be saturated for long periods of time, or the paint will eventually begin to peel off. If you are careful not to keep brush handles or metal ferrules submerged in water for too long, you will greatly minimize brush shedding and paint peeling.

BRUSH CLEANING
For most of us, brush cleaning is not a favorite chore. However, cleaning your brushes is necessary for keeping them in good, usable condition. Start by wiping all excess paint from your brush. Gently rinse it out with warm water by stroking the brush back and forth in the palm of your hand under a running faucet.

Tip Paint with the highest quality brushes, paints and canvases you can afford. Professional-grade materials really do make a big difference in the quality of your work. If you are just starting out, however, it is fine to begin with student-grade materials and work your way up to using professional grade as your skills develop and improve.

Then, work some brush soap or a good dish soap (I prefer Dawn) into the bristles with your fingers. Massage gently from the ferrule to the tip. Do this until all paint residue is out of the brush. Be careful never to smash the bristles down or scrub them—only use gentle back-and-forth strokes in the palm of your hand. Once the brush is clean, dry it with a paper towel, and lay it down flat until it has dried thoroughly.

BRUSH STORAGE

After you finish cleaning a brush, never leave it standing up to dry. Always dry it with a towel and lay it down flat. If you leave your brushes standing up, water will settle at the base of the ferrules, softening the glue over time, which will eventually lead to shedding.

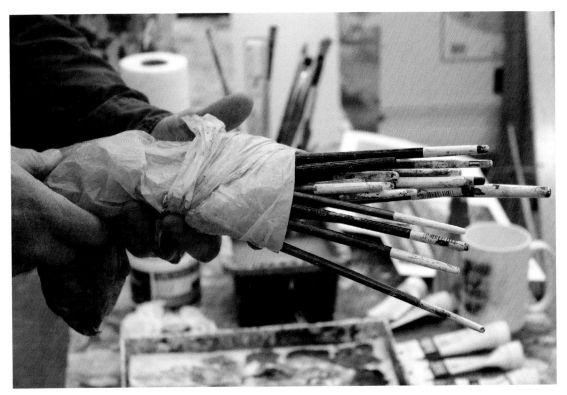

Keeping Brushes Wet

Have you ever been so tired after a day of painting that your eyes could not focus anymore? Or have you ever been so focused on a painting that you painted right through lunch and dinner, then felt so weak and hungry that you couldn't paint one more stroke? Welcome to the life of an artist!

We have all experienced this fatigue to one degree or another, and the last thing you feel like doing is cleaning your brushes. There is a temporary solution to this problem. Simply wet the bristles of your brushes and carefully place them in a plastic bag. Then, wrap the bag around the handles and lay it down flat. You'll be good for a few days. When you're ready to paint again, take the brushes out, rinse them off and you are ready to go. Your brushes will stay nice and soft.

This system will not appeal to everyone. For many artists, thoroughly cleaning brushes at the end of a painting session is a must. But for myself, and others like me who paint until you drop, this works well for those times when you're just completely out of steam. However, I do stress that this should be done only as an occasional alternative to brush cleaning. I do not recommend keeping brushes wet for long periods of time, as continuous wetness will contribute to brush shedding or paint peeling off the brush handle.

Acrylic Paints

Acrylics are ideal for exhibiting and shipping. An acrylic painting can be framed and ready to ship thirty minutes after it is finished. You can apply varnish over acrylic paint or leave it unvarnished because the paint is self-sealing. Acrylics are incredibly versatile. The pigments can be applied to resemble oil or watercolor paints. Best of all, acrylics are non-toxic, have minimal odor and are typically hypoallergenic.

Most paint manufacturers make three grades of paints: economy, student and professional. The professional grades are the most expensive, but they are archival and the most effective to work with. If you are just beginning or on a budget, student-grade paints are a decent middle-of-the-road option. Like most things, you get what you pay for. The main idea is to buy the best quality you can afford, and have fun. I prefer to use Liqui-tex Professional Heavy Body Acrylics; however, there are many good brands available. Experiment to find what you are most comfortable with. Just make sure you use heavy body paints.

The most common criticism of acrylic paints is that they dry too fast. While acrylics do dry very quickly, I've found that keeping a wet palette system solves this problem. I also use very specific dry-brush techniques to make blending easy. If you follow the techniques and methods used in this book, you can overcome any of the fast-drying problems acrylics seem to pose.

USING A LIMITED PALETTE

I work with a limited palette. Whether for my professional pieces or for instructional purposes, I have learned that a limited palette with the proper colors is one of the most effective tools for painting. This type of palette teaches you to mix a range of shades and values of color. It also eliminates the need to purchase dozens of different paint colors, which is much kinder to the wallet!

I keep the following colors on my palette at all times:
- Gesso (for white)
- Cadmium Yellow Light
- Cadmium Orange
- Cadmium Red Light
- Hooker's Green
- Burnt Sienna
- Burnt Umber
- Ultramarine Blue
- Turquoise Deep

- Dioxazine Purple
- Alizarin Crimson
- Vivid Lime Green or Phthalo Green (Yellow Shade)

For brighter, intense reds, you can also use Naphthol Crimson and Cadmium Red Deep.

This particular palette is extremely versatile. With a few pigments and a little knowledge of color theory, you can paint anything you desire. All you need is a basic understanding of the color wheel, the complementary color system and value to mix thousands of colors.

For example, you can mix Phthalo Green and Alizarin Crimson with a touch of white to create a pale flesh tone. These same three colors can also be used in combination with other colors to create earth tones for landscape paintings. The possibilities are endless.

Tip Throughout this book, I will refer to the consistency of your paint for various applications. For example, if I suggest a creamy or buttery consistency for certain applications, simply add water and mix with a palette knife until the paint forms a soft, butter-like consistency. If I mention thinning your paint to an ink-like consistency for your script brushwork (tree limbs, weeds or any other fine-line work), I am referring to a thin watery consistency. In that case, you would continue adding water until the paint becomes fluid and thin, like ink.

ACRYLIC PALETTE LAYOUT

Palette setup is an individual process based on each artist's medium, style, technique and color schemes. As you develop your own techniques over time, you will eventually find the layout that is most comfortable for you. However, there are some basic concepts that can help you get started. I recommend the fairly common, basic palette layout shown below.

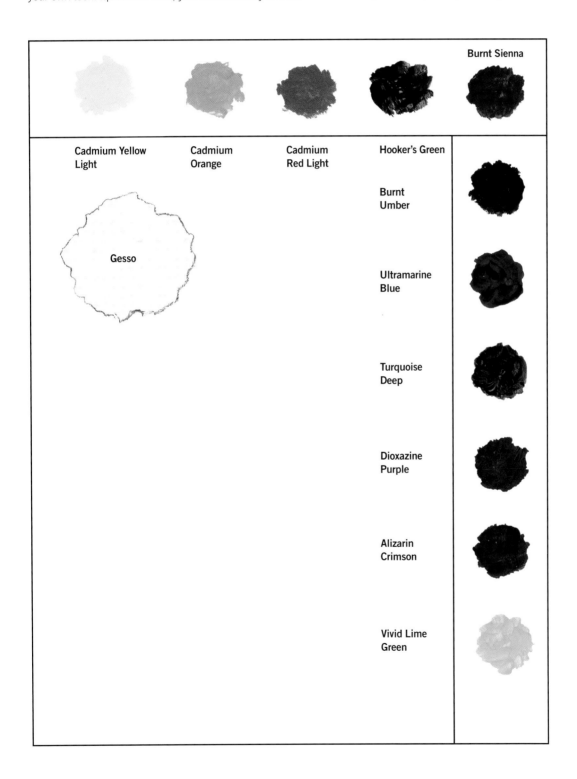

Gesso vs. Titanium White Acrylic Paint

Gesso was originally developed as a primer/sealer for raw, unprimed canvases and other painting surfaces. It can be purchased as either acrylic or oil gesso, and it comes in various consistencies, depending on its intended use and quality. You can also buy gesso as a powder that can be mixed as either oil or acrylic based.

While it is still primarily used for priming painting surfaces, gesso has slowly evolved into a painting medium for mixing with pigments to create colored gesso. This method has many uses for underpainting and tinting painting surfaces.

With all that being said, for me, gesso has an additional, very important function. I prefer to use thick, heavy-bodied white gesso as my white paint color instead of the usual Titanium White acrylic pigment. The main problem with using Titanium White paint is that it has a plastic-like appearance once dry. Many artists dislike this effect so much that it causes them to give up on using acrylic altogether. However, there is good news! When white gesso is used in place of Titanium White acrylic,

you can create a soft, blended, oil-like effect without the plastic look. Once you varnish an acrylic painting that uses gesso instead of Titanium White, you can hardly tell the difference between the two. (In fact, I have actually had art judges challenge me on occasion, believing that my work was oil-based instead of acrylic.)

You can also use gesso to create texture simply by applying it thickly and leaving visible brushstrokes. The use of gesso instead of Titanium White is not a requirement, but using a heavy-bodied gesso will allow you to create some nice oil-like effects in your acrylic paintings.

Gesso Brands
I prefer to use Grumbacher Gesso, but there are several brands available at various price points. Experiment to find the brand that works best for you.

Tip If you leave your paint sealed for many days without use, some colors can become moldy. It is a good idea to open the lid and check them now and then if you have not used them for a while. You can replace the molded colors as needed.

Palette Systems

I recommend using a 12" × 16" (30cm × 41cm) Masterson Sta-Wet Palette. You can buy one with or without a sponge (I prefer not to use the sponge). Instead, lay a piece of acrylic paper in the bottom of the palette and place folded paper towels around the edge to form an L-shape. Wet the paper towels so they are fairly saturated but not soupy. Then, arrange the paints on the wet towels in your preferred order.

Throughout your day of painting, occasionally mist the paper towels with a spray bottle to keep the paints moist. When you are finished painting, simply attach the air-tight lid. Your paints will stay wet for days, limiting the amount of wasted paint.

You can also use a glass palette system to keep your paints moist. Take a Sta-Wet Palette and use a cut-to-fit piece of double-strength glass in place of the acrylic paper. When you need to clean the palette between mixtures, simply spray the glass with your mister bottle. Let it sit for a few seconds, and then scrape off the paint with a single-edge razor blade or a paint scraper.

Both systems work well and are a great way to save paint. I have left paints in my palette savers for weeks, and they never dry out.

Sta-Wet Palette Setup
Place palette paper in the bottom of the Sta-Wet Palette box. Fold paper towels into fourths and place them along the edges to form an L-shape. Wet the paper towels with a mister bottle.

My "Dirty" Palette

Canvases

There are so many different types of canvases available that choosing one can be confusing and overwhelming. As with most products, there are several qualities and price ranges to choose from. It all depends on what you are trying to accomplish. If you are still learning, or just practicing with quick studies, it's fine to use a cheaper canvas. But when you are ready to do your best work, buy the best canvas you can afford.

Often, choosing the correct canvas depends on what it is you want to paint. For most landscape painting, I recommend the medium duct cotton canvas. However, if you want to paint more detailed close-ups of animals and birds, then the tighter weave portrait smooth canvas would be best.

Here are a few tips to help you make the right decision. All of the canvases discussed here are pre-primed and ready to paint on, so there is no preparation needed. However, I do recommend that you lightly sand the canvas with a fine-grit sandpaper to knock down any rough spots that may interfere with blending.

MEDIUM DUCT COTTON CANVAS

This is a common canvas for oil and acrylic painters. It is not too rough or too smooth and works well for artists who like to use thicker paints with a brush or palette knife. It works great for landscape painters and most impressionistic techniques. I recommend Fredrix Medium Texture Red Label Cotton Canvas. It may be a bit expensive, but it is a high-quality, durable canvas. It is pre-primed and ready to work on and comes in all standard sizes.

PORTRAIT SMOOTH CANVAS

If you are more into portraits or other, more detailed subjects and you want a smoother, more refined appearance, I suggest you use a less coarse, more refined, tighter weave. I recommend the Fredrix Ultra Smooth Portrait Grade Blue Label Canvas. This is a high-quality, pre-primed canvas perfect for more detailed projects. It also comes in all of the standard sizes.

Both of these canvases are standard profile canvases. This means the canvas has been stretched on wooden stretcher bars that are 1¾" (44mm) wide and ¾" (19mm) thick. These are what you would use if you want to frame your painting.

GALLERY WRAP CANVAS

If you do not want to frame your painting, you could use a gallery wrap canvas. This canvas has been stretched on stretcher bars that are 1½" (38mm) thick, or more. You can paint the edge any color you want or wrap the painting around the edges of the canvas. Then you don't have to frame the painting. This type of canvas has become very popular.

CANVAS BOARD

Canvas board is made of canvas that has been glued to a dense pH-balanced type of cardboard. It's great for practicing techniques as well as finished paintings. I like to use these for my smaller paintings. My favorite is Fredrix Archival Canvas Board.

Fredrix High Quality Medium Duct Cotton Canvas
This is my favorite canvas for painting landscapes.

Stedi-Rest System

If you want or need to do a lot of detail work, but you don't have a steady hand, Masterson's Stedi-Rest system can be a real game changer. It is simple to install on your canvas and easy to use. The Stedi-Rest system consists of a plastic strip about 17" (43cm) long with slots that are about ½" (13mm) apart. The slots hold a mahl stick in place, which you can then rest your hand on as you paint. This is a great tool for keeping your hand steady while allowing you to be more comfortable and less fatigued.

Normally you place one Stedi-Rest strip on either side of the canvas to hold the mahl stick in place. However, if you have a lot of very fine close-up detail, you can attach Stedi-Rest strips on two sides of the canvas. Then you can place your mahl stick level across the canvas and slide your hand back and forth as you paint.

Traditional Use of the Stedi-Rest System
A Stedi-Rest strip is attached to the side of the canvas with a thumb screw. One end of the mahl stick rests in a slot while the artist holds the other end, creating a rest for the hand.

Alternate Use of Stedi-Rest
Stedi-Rest strips have been attached on two sides of the canvas. The mahl stick lays horizontal across the painting to allow for easy back-and-forth hand movement.

Other Materials

Following are descriptions for some other important and useful supplies you will need to complete the painting demonstrations in this book.

SOFT VINE CHARCOAL

This is the preferred sketching material for making rough sketches on canvas. Soft vine charcoal removes easily with a damp paper towel without leaving any residue. NOTE: I do not recommend you use hard-lead pencils or hard charcoal sticks for sketching as they are more difficult to remove and often leave marks or residue.

CONTÉ SOFT PASTEL PENCILS

These pencils are a soft French pastel in pencil form. They are soft but can still be sharpened to a fairly sharp point for more delicate sketches, like birds, people, animals, etc. Also, they can be easily erased.

PALETTE KNIFE

Palette knives come in multiple types and have many uses. Some artists paint with them, some apply texture with them, some sculpt with them, but most of us just need a palette knife to mix our colors. A good mixing knife should be flexible with a trowel-shaped handle. It should have about a 3"–4" (8cm–10cm) mixing blade with a handle about 7"–8" (18cm–20cm) long. You can buy plastic or metal knives. I prefer a metal knife because it is more flexible and durable.

MAHL STICK

A mahl stick is nothing more than a long dowel rod about 36" (91cm) long that you rest along the side of the canvas or use with the Stedi-Rest system to steady your hand for detail work. You can buy very expensive metal or wood mahl sticks, or you can go to your local hardware or craft store and buy a wooden dowel rod for a dollar or two. Some of my students prefer a metal, collapsible mahl stick, which can be folded up neatly for packing or travel.

FINE-GRIT SANDPAPER

I use a fine-grit sandpaper for lightly sanding my bare canvas to knock down the tooth and any flaws. You can also use fine-grit sandpaper for lightly sanding brush hairs off of your finished painting.

TOOTHBRUSH

Yes, a toothbrush. It works great for more than brushing your teeth. You can use one to create sand, snowflakes, mist, splashes at the base of a waterfall, small pebbles, dirt and gravel. Throughout the book you will see most of these applications explained.

Palette Knife

White Conté Pencil

Studio Setup

Your studio setup might not seem terribly important; however, in my own experience, an improper studio setup can make the painting process unnecessarily difficult. Everything from proper lighting to the kind of chair you sit in can make a huge difference in the quality of your work and your artistic mood. Of course, not everyone can afford a large, professional studio, so here are a few tips for those who are short on space and money.

- If possible, find a space that is large enough for you to be able to stand at least 6 feet (2m) back from your work.
- Use a wooden or aluminum easel that is stable and does not wiggle or move around as you work. I use the Stanrite 500 aluminum easel. It is very sturdy, yet lightweight, and folds up easily for transportation.
- If all you have room for is a table-top easel, that's OK. Just be sure it is heavy duty, and attach it to your table to keep it from moving around. There is nothing more frustrating than an easel that won't stay in place!
- Good lighting is essential. A standard lamp, or even a headlight, is not sufficient to give you even lighting without casting shadows. I prefer to hang two 4' (122cm) double-bulb fluorescent lights about 2 feet (61cm) above my easel. I put a warm light bulb and a cool light bulb on each fixture to simulate daylight and cut down on shadows. This arrangement provides an even distribution of light.
- I recommend a good, comfortable padded chair with a high back and rollers. That way you can easily roll back and view your work. I use an executive high-back office chair with adjustable arms and seat height.
- If you prefer to stand, you may want a padded stool to lean back on. Also, standing on a cushioned mat will help cut down on fatigue and achy joints.

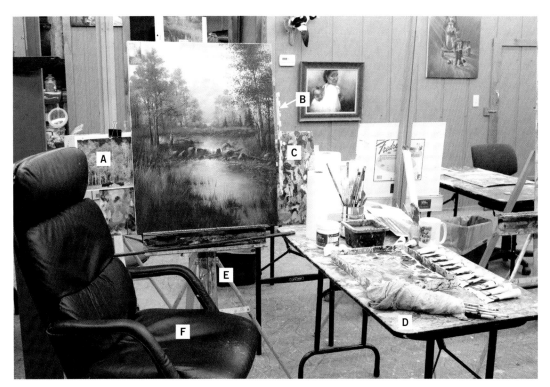

My Studio Setup
A: reference material; B: Stedi-Rest system; C: dabble board; D: supplies table, E: Stanrite aluminum easel; F: comfortable padded chair with wheels

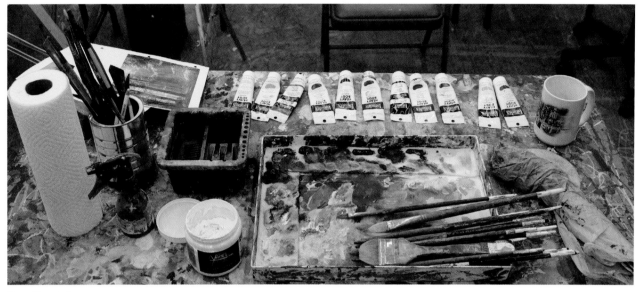

Supplies Setup

I strongly recommend placing a large table next to your easel to keep all of your supplies organized and within easy reach.

Tip If you are unable to install the recommended type of lighting because of limited space, you can purchase a light known as an OttLite. These are made specifically for artists and can be clipped onto your easel or used as a free-standing pole lamp.

Dabble Board

Every artist needs a dabble board. A dabble board is nothing more than a canvas board for testing colors and mixtures on. I usually set mine on the easel so I can slide it back and forth behind the painting.

Organizing & Storing Reference Materials

In this age of modern technology, there are seemingly endless options for researching and storing reference materials, including smartphones, digital cameras, computers, tablets and so on. While these are all great resources, most require a power source, so they are not always convenient to use. My experience has taught me that most artists prefer to use physical copies of reference photos that can be marked and held close to the easel as they work.

I have been using the same reference system for thirty years, and it works very well for providing quick access to reference for the subjects you need to compose your painting. Below are some tips that can help you organize and use your research material more effectively. You will need:

- 3-ring binders (Use any size you wish. I prefer 1"–1½" [3cm–4cm].)
- 8½" × 11" (22cm × 28cm) card stock/index paper
- 3-hole punch
- Transparent scotch tape or Elmer's glue (Don't use glue sticks. They dry out, and the photos come loose.)
- Markers or a label-maker
- Reinforcement labels for the punched holes
- Scissors or craft knife for trimming photos
- Tab dividers to separate categories within the books
- Reference photos

Once you have gathered your materials, separate your photos into categories (i.e., Birds, Animals, Trees, Rocks, Mountains, Rivers, etc.), then label each book with that category and a number.

Trim your photos to fit the card stock. Tape them in place on the front and back. I recommend keeping similar subjects together on the same page. Write the number of the book at the bottom of each page. This will be especially helpful when you are working on a painting that has multiple reference sheets. Finally, put the reference sheet back in the binder with the same number. This saves time and confusion when re-filing your reference material.

Simply place your books and/or categories in alphabetical order, and you'll be ready to begin researching when it's time to start your next painting.

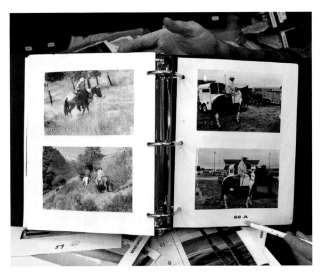

Organizing Reference Material
The labels and numbers on the reference photo pages match the label and number on the spine of the binder.

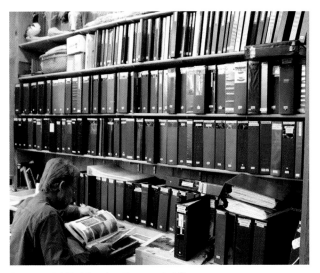

Jerry and His Massive Research Library
All binders are labeled, numbered and in alphabetical order, which makes them easy both to locate and re-file.

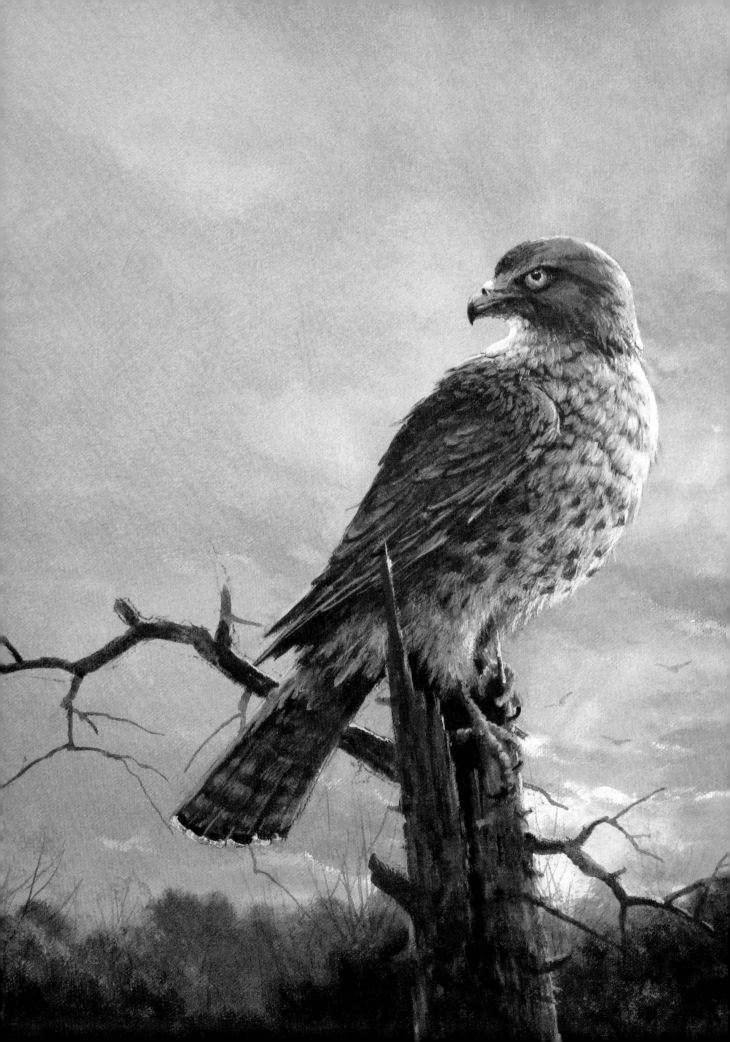

Chapter 2

Techniques

A technique is the process you use to achieve a specific effect. Throughout this book, you will hear me use different terms like scumbling, drybrush, feathering, underpainting, graying, dabbing and so on. These are all techniques used to create atmosphere, depth, texture and blending.

This chapter explores the various concepts and techniques you will need to apply to complete the painting demonstrations that follow. In addition, it offers advice and tips for color mixing and developing your composition. You will gain a solid foundation for all of the basics required to create a beautiful fine art painting.

In Honor of Thomas
Acrylic on gallery wrap canvas
12" × 16" (30cm × 41cm)

Terms

The following terms are used throughout this book to describe various painting methods and techniques. If you familiarize yourself with these terms now, it will help make the painting process a bit easier.

ACCENT HIGHLIGHT

The finishing highlight that brings the tonal value up to its full light value. It is usually two or three values lighter than the form highlight.

DABBING

A brush technique that can be used to create leaves, ground cover, flowers and texture. Dab the tip of a bristle brush on a table or palette until it fans out, then load the paint and begin dabbing the brush tip on the canvas to create the desired effect.

DOUBLE LOAD/TRIPLE LOAD

A blending process where more than one color is applied to different parts of the brush tip, then mixed directly on the canvas instead of on a palette. This works great for mottled objects like rocks and dirt, as well as certain still-life objects in cases where a pre-mixed color or value is not as important.

DRY-BRUSH BLENDING

Also known as feather blending, this brush technique can be used to apply soft highlights, details and multiple layers of glaze. Any type of brush will work for this, depending on the object and size of the area you are painting. Simply use a small amount of paint and very light pressure to gently skim across the tooth of the canvas and leave a soft highlight. Dry-brush blending usually requires multiple layers to achieve the brightness you desire.

FORM HIGHLIGHT

This highlight is only about one to two values brighter than the underpainting. I often use this term after an object has been underpainted and is ready for the first dimensional highlights that establish its basic form.

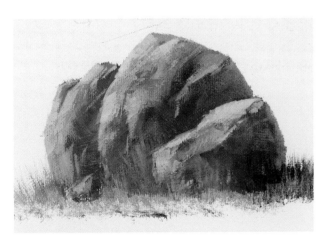

Accent Highlight with Final Details

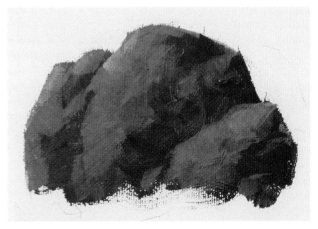

Form Highlight

GLAZING

Also known as a wash, this process uses a very thin mixture of water with just enough pigment to create a soft tint. A glaze or wash is usually applied with a hake brush, but other brushes such as large bristle flats can also be used. Glazes have a slightly milky tint, which makes them useful for tinting an entire painting, creating softness or atmosphere in certain areas of a painting, toning down objects that are too bright or creating fog, mist, haze and smoke.

NEGATIVE SPACE

There are two types of negative space: outer negative space and inner negative space. Outer negative space consists of the pockets of negative space that surround an object and give it form. Inner negative space is pockets of space that form the inner areas of the object.

SCRUBBING

A brush technique used for underpainting and highlighting objects like rocks, trees and dirt. It is usually done with a bristle brush and heavier pressure to create a basic rough form and form highlights. It should not be used for detailing or other finishing work—only for basic form building.

SCUMBLING

A brush technique used for creating various objects such as clumps of leaves and other foliage, clouds, curly hair and grasses. It is nothing more than a series of unorganized, overlapping strokes that create the suggestion of a form. It also works great for creating mottled backgrounds. Scumbling can be done with any size and type of brush.

VALUE

The relative lightness or darkness of a color. Value is used to create depth, distance and dimensional form.

WET-ON-DRY

A paint layering technique where you allow the area you've just painted to dry completely before applying the next layer of paint. This is the layering technique I use most often in acrylic painting, especially for highlights and details.

WET-IN-WET

A technique used to layer and blend paint simultaneously. The next layer of paint is applied while the first layer is still wet, then the shadows and highlights are blended together. This technique works well for creating clouds, rocks or any other area that needs dimensional blending.

UNDERPAINTING (BLOCKING IN)

The process used to establish the darker areas of a painting to prepare them for the later layers of highlights and details.

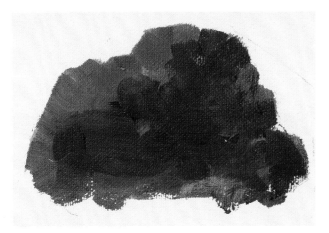

Underpainting (Blocking In)

Value

A proper value system is a crucial component of a painting. Before you can master how to mix and use values, you must first understand that there are two different types of value systems.

CREATING DEPTH

The first type of value is value used to create depth or distance in a painting, specifically a landscape with multiple layers of hills and trees. The general rule for creating depth in a painting is that objects in the background are cooler in tone, less intense in color, softer, less detailed and lighter in value. As you move into the foreground, objects become gradually warmer in tone, more intense in color, more detailed and darker in value.

CREATING FORM

The second type of value is value used to create the form or dimensional shape of an object. A standard form value system consists of at least three values: dark value, middle value and light value. Of course, there will be gradation values between each of these to transition one into another. These transitional values allow the eye to flow gracefully across or around an object so that there are no hard or defined edges.

Below are examples of value changes in a normal landscape. Most landscapes will have between three and seven value changes. It all depends on the time of day, the direction of the light source and the amount of depth you want to achieve. The general rule is that the more value changes you have, the more depth you will create.

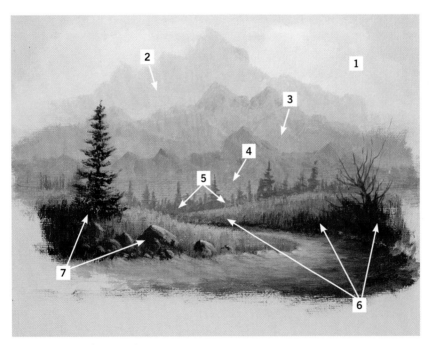

Values for Creating Depth
Value 1: sky; Values 2, 3, 4: distant mountains; Value 5: distant pine trees; Value 6: middle-ground objects; Value 7: foreground objects

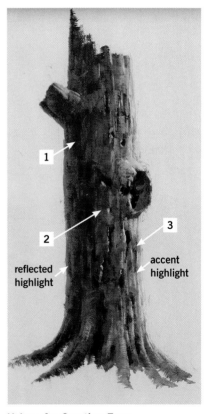

Values for Creating Form
Value 1: dark; Value 2: medium; Value 3: light; accent highlight; reflected highlight

The Grayscale

The grayscale is a system artists use to determine the intensity or value of a color. Most art schools require students to create and study the grayscale before they are allowed to begin working with full color. Students create simple black-and-white paintings with multiple values suggesting depth (distance) in a landscape or in the dimensional form of an object.

This system works for every color and color mixture you can create. For the painting demonstrations in this book, you'll find the grayscale below extremely helpful in determining the proper intensity of all the color formulas I have provided.

For example, if I recommend using a medium value dark green mixture, all you have to do is add just enough white to the Dark Green formula (1 part Hooker's Green + ¼ part Dioxazine Purple) to change the value to match the medium value on the grayscale. It's that simple!

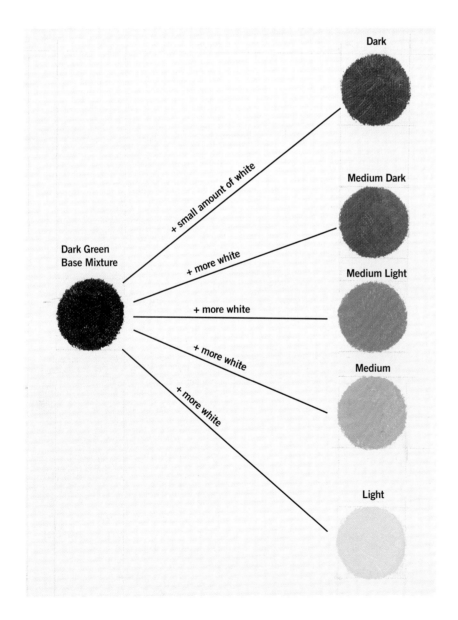

Dark

Medium Dark

+ small amount of white

**Dark Green
Base Mixture**

+ more white

Medium Light

+ more white

+ more white

Medium

+ more white

Light

Use the Grayscale to Change the Value of a Basic Mixture by Adding White
Only use this system to change the value of a color mixture. Depending on the painting, time of day, location of the light source or season, you may have to slightly alter the color or value.

Color Mixing

The following basic color formulas and mixtures can be used for a wide range of paintings, including all of the painting demonstrations in this book.

MIXING BLACKS

Many artists use black paint right out of the tube. However, this tends to be a lifeless black, so I recommend mixing your own blacks. The best thing about mixing your own blacks is that you can vary the temperature and hue.

After you create a black mixture, it can be difficult to know exactly what hue the black is. To see the hue, simply add a small amount of white to the edge of the mix, and the color will instantly appear. This is a great method for testing hues and makes it easy to adjust your color as needed.

Even after you have created a basic black mixture, you can still add other colors to change the hue or temperature. For example, to make a black warmer, add more Burnt Sienna or some other warm color. To make a black cooler, add more Ultramarine Blue or other cool color.

Let's take a look at a few of my most commonly used black mixtures.

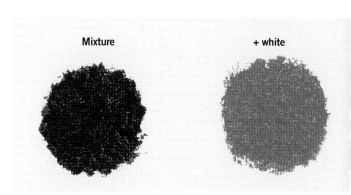

Basic Black Formula
Mix 1 part Burnt Sienna and ½ part Ultramarine Blue. This simple mixture creates a generic black for multiple applications. In its dark form it is neither warm nor cool, and when tested with white, it turns into a nice neutral gray. This mixture has many uses because of its neutral tone.

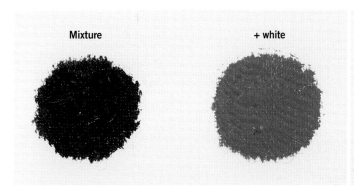

Black With Turquoise Tint Formula
Mix equal parts Burnt Umber and Turquoise Deep. This creates a black that is rich, deep and soft. It is deeper in tone than the basic black formula, but when you test it with white, you'll notice it has a slight greenish tint.

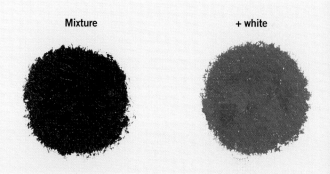

Midnight Black Formula
Mix 1 part Burnt Umber, 1 part Turquoise Deep and ¼ part Dioxazine Purple. This creates an exciting, dark black that works especially well for a midnight sky. Although this mixture is similar to the first two formulas, it has some purple in it.

MIXING COLORS

You can use these basic color mixtures as the foundation for many paintings. Of course, any of these can be changed based on your particular color scheme. Be open-minded and willing to make adjustments as needed.

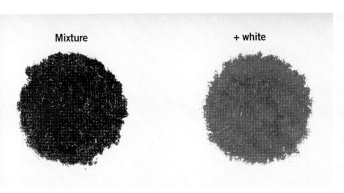

Dark Green Formula

Mix 1 part Hooker's Green, ⅛ part Dioxazine Purple and ⅛ part Burnt Sienna. This creates a deep forest green that can be used for underpainting leaves, grasses, bushes and meadows.

Medium Green Formula

Mix 1 part Hooker's Green with ¼ part Cadmium Orange and a touch of Cadmium Yellow Light. This creates a medium green that can be used for middle-tone highlights on leaves, grasses, bushes and meadows.

Light Green Formula

Mix 1 part Vivid Lime Green with touches of Cadmium Orange and Cadmium Yellow Light. This creates an accent or final highlights on leaves, grasses, bushes and meadows.

Basic Gray Formula

Mix 1 part Burnt Sienna and ¼ part Ultramarine Blue with a touch of Dioxazine Purple and white. This creates a basic gray that can be used for underpainting rocks, tree trunks, mountains, wooden objects and animals.

Dark Brown Formula

Mix 1 part Hooker's Green with ¼ part Alizarin Crimson and a touch of Cadmium Orange. This creates a basic brown that can be used for underpainting warm, dark autumn tones on dirt banks, rocks, tree trunks, leaves or bushes.

Medium Brown Formula

Mix 1 part of the Dark Brown formula with touches of Cadmium Yellow Light and Dioxazine Purple. This creates a basic tan that can be used for underpainting sand, dirt, animals and other areas of the painting that require a soft, warm, light undertone.

Light Brown Formula

Mix 1 part white with ⅛ part Cadmium Orange and a touch of Ultramarine Blue. This creates a basic color for accent and final highlights to be used for most structures like rocks, tree trunks, mountains, wooden objects and some animals.

Basic Purple Formula

Mix 1 part white with ¼ part Dioxazine Purple and ¼ part Ultramarine Blue. This creates a reflected highlight tone for the accent highlight on the shadowed side of rounded objects like rocks, tree trunks, fence posts and body parts. This mixture is specifically designed to soften the hard edges of the shadows of these objects.

Basic Blue Formula

Mix 1 part Turquoise Deep with ⅛ part Ultramarine Blue and ⅛ part Burnt Umber. This creates a basic mixture for underpainting lakes, ponds, streams and other deep bodies of water.

Pale Flesh Tone Formula

Mix 1 part white with touches of Cadmium Orange and the Basic Gray formula. This creates a basic highlight color for highlighting most objects after the form highlight has been applied.

Graying a Color

If you need to kill the purity of a color, you can gray it down by mixing in a touch of its complementary color. For example, if you're using yellow as an accent or highlight and it's too bright for that area of the painting, neutralize it by adding a touch of its complement, purple. Or let's say you have a blue-gray mixture that is too strong. You could gray it by adding a touch of Cadmium Orange or some form of an orange mixture.

Cadmium Yellow Light + Complement Purple

True Color Grayed Version

Dioxazine Purple + Complement Yellow

True Color Grayed Version

Cadmium Orange + Complement Blue

True Color Grayed Version

Ultramarine Blue + Complement Orange

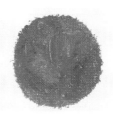

True Color Grayed Version

Cadmium Red Light + Complement Green

True Color Grayed Version

Hooker's Green + Complement Red

True Color Grayed Version

Graying Your Canvas

Although you can purchase canvases that are pre-primed with white gesso and ready to paint on, most professional artists prefer to use a neutral canvas with either a warm or cool grayish base. Stark white is a distraction to color; gray is a neutral tone to which the eye adjusts easily. The purpose of a gray canvas is to kill the white surface so you can see colors and values better.

This same principle applies to your palette, too. Many people make fun of my dirty palette, until they try one and see how well it works.

The following mixtures are the basic gray tints I use for graying my canvas.

Warm Gray Canvas Tint
Mix 1 part gesso, ¼ part Burnt Umber and ⅛ part Ultramarine Blue.

Cool Gray Canvas Tint
Mix 1 part gesso, ¼ part Ultramarine Blue and ⅛ part Burnt Umber.

Mauvish-Gray Canvas Tint
Begin with either the warm gray or cool gray formula and add a little bit of Dioxazine Purple.

Greenish-Gray Canvas Tint
Begin with either the warm gray or cool gray formula and add a little bit of Hooker's Green.

Anatomy of Painting

Paintings are kind of like the human body. Both are made up of many parts. The body has a head, a neck, a torso, arms, legs and feet. You can look at a painting in a similar way. The illustration below shows you how to break your landscape painting down into various segments so you can create better distance and depth in your artwork.

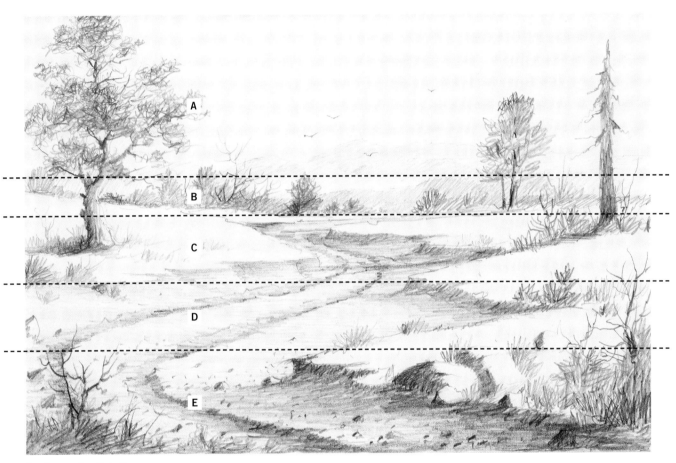

Anatomy of a Painting
A: background; B: middle background; C: middle ground; D: middle foreground; E: foreground

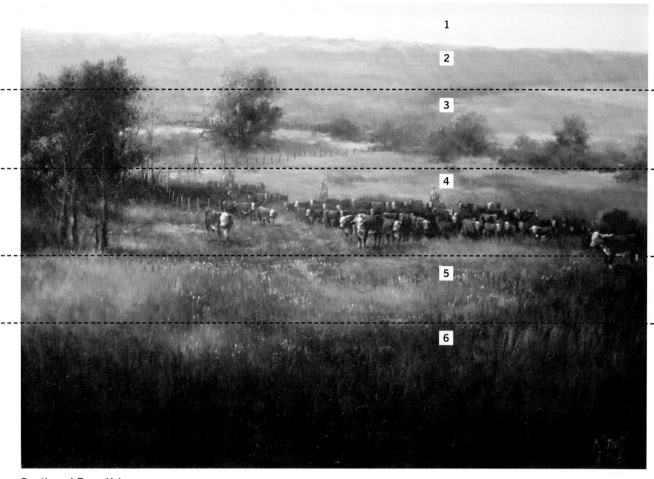

1

2

3

4

5

6

Depth and Form Values

1–2: sky and distant objects (hills, trees); 3: miscellaneous distant trees; 4: center of interest (cattle); 5: miscellaneous details (flowers, grasses); 6: immediate foreground objects

Order of Segments		Approximate Value Number per Segment
1–2	Background	1
3	Middle Ground	2–3
4	Center of Interest (Middle Ground)	4–5
5	Middle Foreground	6
6	Immediate Foreground	7

 Tip Most full-scale landscapes have between three and seven value changes that coincide with these segments of the painting. Each painting has its own value system based on time of day, atmosphere, season, light source and so on. Use lighter values in the background and darker values as you move into the foreground. Keep an open mind and do not be afraid to use your artistic license to achieve the effect you want.

Composition & Design

Composition is the arrangement of objects, subjects and ground contours on your canvas to create graceful eye flow without bouncing from object to object or getting hung up on distractions. It is the most important element in creating any type of artwork. It is truly the foundation of the creative process.

The very first art award I ever won was because my painting had a strong composition. The judge said to me, "I am giving you first place not because I like your painting so much—frankly, it is not painted very well. However, the composition is so strong that it drew me in and held my attention, and my conscience won't allow me not to give you the first place award." For me, it was a career-changing moment that confirmed just how critical composition is.

So let's take a look at some of the key elements of composition that should be present in all of your paintings. We will only cover the basics, but this should give you an understanding of how everything works together in unison to create a well-balanced piece of art.

CENTER OF INTEREST OR FOCAL AREA

All artwork needs a center of interest or focal area. The center of interest is the object that attracts the eye and holds the viewer's attention. It can be a single object or a tightly grouped series of objects. The purpose is to get the viewer to see the object/objects as the most important part of the painting. Everything else in the painting should be non-competitive and serve to guide the viewer's eye toward the center of interest.

A focal area also draws in and holds the viewer's attention, but it is not typically an object. Rather, it might be a beautiful sunset with rays reflecting on a lake or ocean or a winding pathway or road leading back to a beautiful waterfall or snow-capped mountains in the distance—these are all focal points. Everything else is just filler leading the eye toward the focal area.

Overlapping in the Focal Area Helps Eye Flow
Notice the way the subjects overlap in the focal area of the painting. This helps create good eye flow.

EYE STOPPERS

Eye stoppers are generally located in the lower corners or at the sides of a painting. They stop the eye from wandering off the canvas. These are usually non-competitive fillers like tall weeds, small, twiggy bushes, rocks or trees with limbs painted toward the focal area of the composition. Even simple dark shadows in the corners with no detail can work as eye stoppers sometimes.

NEGATIVE SPACE

There are two types of negative space. Outer negative space surrounds an object and gives it form. Inner negative space is the space or spaces within an object that give the object detail. The pockets of space in the canopy of a leafy tree or bush, the folds and wrinkles in material or cracks and crevices in a rock or mountain are examples of inner negative space.

FILLERS

Fillers are the objects that fill up the areas around the focal area. These are the items that complete the painting and help guide the viewer's eye toward the focal area or center of interest without competing with the main areas of interest. They can also be used to help define the season, time of day, atmosphere and so on. Examples of fillers include trees, bushes, meadows, water, dirt, rocks, distant hills or mountains and weeds. Just remember, they serve only to support the focal area, not compete with it.

LIGHT SOURCE AND SHADOWS

Every composition has a pre-determined light source. This is important because the location of the light source will cast shadows that greatly affect the compositional eye flow. For instance, bright sunlight creates shorter, softer shadows; low sunlight creates longer, more intense shadows. Choose what works best for your painting.

OVERLAPPING

Overlapping is when you have multiple smaller objects grouped together and arranged so they overlap each another. This creates pockets of negative space and helps eye flow, as opposed to lining up objects all in a row, evenly spaced and similarly shaped.

PLANES AND PROPORTIONS

Use planes to add individual, proportional objects throughout a painting. For example, if you have an object on the right side of the painting and want to add another object of the same proportion on the left side, draw a horizontal/parallel line from the base of the object all the way across the canvas. That is the plane. Now any object you paint on that plane, using what we call "artistic common sense," should be in proportion to everything else on that plane.

Poor Use of Negative Space
There are no interesting pockets of negative space within the tree leaves, so the viewer's eye zips around the image instead of flowing gracefully.

Good Use of Negative Space
Pockets of negative space placed throughout the tree leaves add interest and create good eye flow.

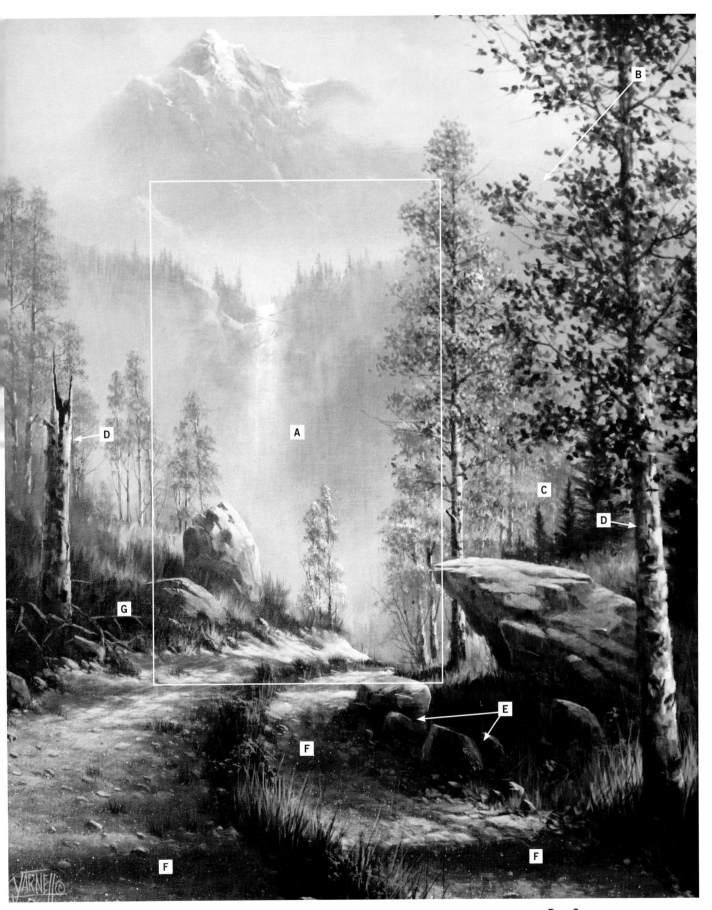

Key Elements of a Composition

A: focal area; B: light source; C: good use of negative space; D: eye stopper; E: overlapping objects;
F: cast shadows; G: fillers

Deep Serene
Acrylic on stretched canvas
12" × 10" (30cm × 25cm)

39

Painting Fur & Feathers

Frequently, you'll find yourself wanting to add more interest to a landscape painting. In many cases, a bird or a deer can be just the ticket. If you don't have much experience painting wildlife, however, the decision to add an animal to your artwork can be a bit daunting.

It is difficult to break down the process for painting animals into just a few words in a book, but I will share as many useful hints and tips as I can to help you get started. I also strongly recommend that you get some scraps of canvas and practice, practice, practice!

UNDERPAINTING AND HIGHLIGHTING
- Be sure the animal is completely covered with the underpainting color. When you underpaint, pull inward from the edge of the animal to avoid hard edges. Some animals have multiple overlapping colors, so be sure to feather the layers into one another as you underpaint. That way you won't leave edges.
- When underpainting, do not paint all the way to the edges of the forms. Stay slightly inside the sketch. The animals will grow slightly as you highlight and detail them, and you do not want them to get too fat.
- When you begin highlighting fur or feathers, be sure that your brushstrokes follow the contour of the animal's body. Obviously, there are exceptions, so pay close attention to your reference.
- Be sure to begin the highlighting process with thin glazes of color instead of strong opaque tones. Glazes allow the

chance to build up light tones and details gradually. This results in more life-like hair, feathers or fur.
- As you finish highlighting, make sure you end up with three distinct values: dark, middle and light. This will ensure that your animal has good three-dimensional form instead of looking flat.

BRUSHES
The following brushes are the ones I use most frequently when painting animals:
- nos. 2 and 4 bristle flats
- nos. 2 and 4 Dynasty brushes
- no. 4 sable flat
- no. 4 sable round

COLOR MIXTURES AND TONES
Most mammals have brown and gray tones. However, birds cover a wide range of colors from browns and grays to bright reds, yellows, blues, greens and oranges. The following color swatches will help you become familiar with these tones, colors and tints. Keep in mind, these are only basic mixtures. There are literally hundreds of mixtures you can create from these base mixtures. So, have fun experimenting!

Underpainting Tone	Form Highlight Tone	Accent Highlight Tone

Formula for Brown Toned Animals
- Underpainting tone: 1 part Burnt Umber + a touch of Ultramarine Blue
- Form highlight: 1 part underpainting tone + touches of Cadmium Orange and white
- Accent highlight: 1 part white + touches of Cadmium Orange and Ultramarine Blue

Underpainting Tone	Form Highlight Tone	Accent Highlight Tone

Formula for Gray Toned Animals

- Underpainting tone: 1 part Ultramarine Blue + ¼ part Burnt Sienna and a touch of white
- Form highlight: 1 part underpainting tone + ¼ part white
- Accent highlight: 1 part white + touches of the underpainting tone and Cadmium Orange

Underpainting Tone	Form Highlight Tone	Accent Highlight Tone

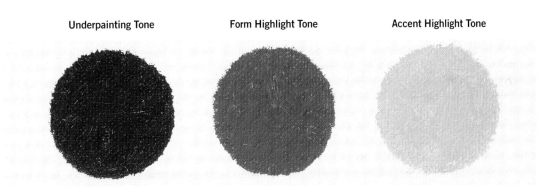

Formula for Reddish Brown Toned Animals

- Underpainting tone: 1 part Burnt Sienna + a touch of Dioxazine Purple
- Form highlight: 1 part underpainting tone + touches of Cadmium Orange and white
- Accent highlight: 1 part white + touches of the form highlight tone and Cadmium Orange

Underpainting Tone	Form Highlight Tone	Accent Highlight Tone

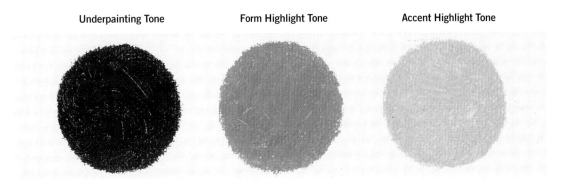

Formula for Black Toned Animals

- Underpainting tone: 1 part Ultramarine Blue + ¼ part Burnt Umber or ¼ part Burnt Sienna
- Form highlight: 1 part underpainting tone + ¼ part white
- Accent highlight: 1 part white + touches of the form highlight tone and Cadmium Orange

| Underpainting Tone | Form Highlight Tone | Accent Highlight Tone |

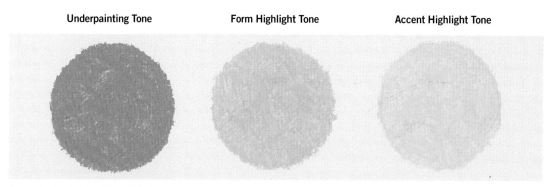

Formula for White Toned Animals

- Underpainting tone: 1 part white + ¼ part Ultramarine Blue and a touch of Burnt Sienna
- Form highlight: 1 part white + a touch of the underpainting tone
- Accent highlight: 1 part white + touches of the form highlight tone and Cadmium Orange

| Underpainting Tone | Form Highlight Tone | Accent Highlight Tone |

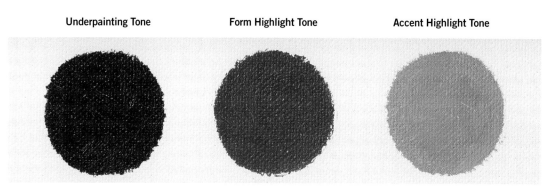

Formula for Red Toned Animals

- Underpainting tone: 1 part Cadmium Red Light + a touch of Dioxazine Purple
- Form highlight: 1 part Cadmium Red Light + a touch of white
- Accent highlight: 1 part form highlight tone + touches of Cadmium Yellow Light and white

| Underpainting Tone | Form Highlight Tone | Accent Highlight Tone |

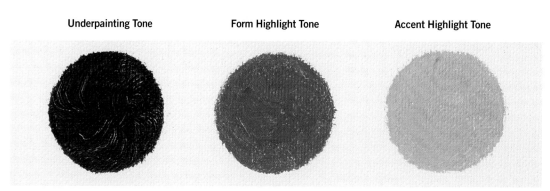

Formula for Blue Toned Animals

- Underpainting tone: 1 part Ultramarine Blue + a touch of Burnt Umber
- Form highlight: 1 part Ultramarine Blue + ⅛ part white and a touch of the underpainting tone
- Accent highlight: 1 part white + a touch of the form highlight tone

Underpainting Tone	Form Highlight Tone	Accent Highlight Tone

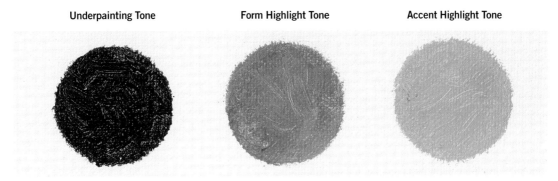

Formula for Green Toned Animals

- Underpainting tone: 1 part Hooker's Green + a touch of Dioxazine Purple
- Form highlight: 1 part underpainting tone + touches of Cadmium Yellow Light and white
- Accent highlight: 1 part form highlight tone + touches of Cadmium Yellow Light and white

Underpainting Tone	Form Highlight Tone	Accent Highlight Tone

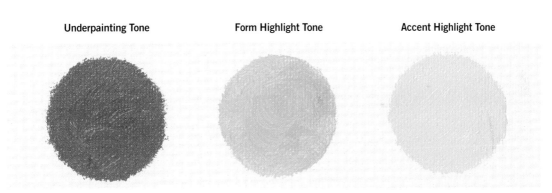

Formula for Yellow Toned Animals

- Underpainting tone: 1 part Cadmium Yellow Light + ¼ part Dioxazine Purple
- Form highlight: 1 part Cadmium Yellow Light + a touch of the underpainting tone
- Accent highlight: 1 part Cadmium Yellow Light + a touch of white

Underpainting Tone	Form Highlight Tone	Accent Highlight Tone

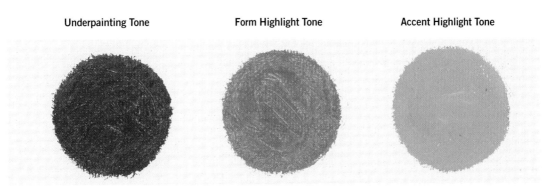

Formula for Orange Toned Animals

- Underpainting tone: 1 part Cadmium Orange + ¼ part Ultramarine Blue
- Form highlight: 1 part Cadmium Orange + a touch of the underpainting tone
- Accent highlight: 1 part Cadmium Orange + a touch of white

Red Toned Animal
A: underpainting tone; B: form highlight; C: accent highlight

Brown Toned Animal
A: brown form highlight; B: brown accent highlight; C: black tones; D: brown underpainting tone; E: white underpainting tone; F: white-ish tone; G: white accent highlight

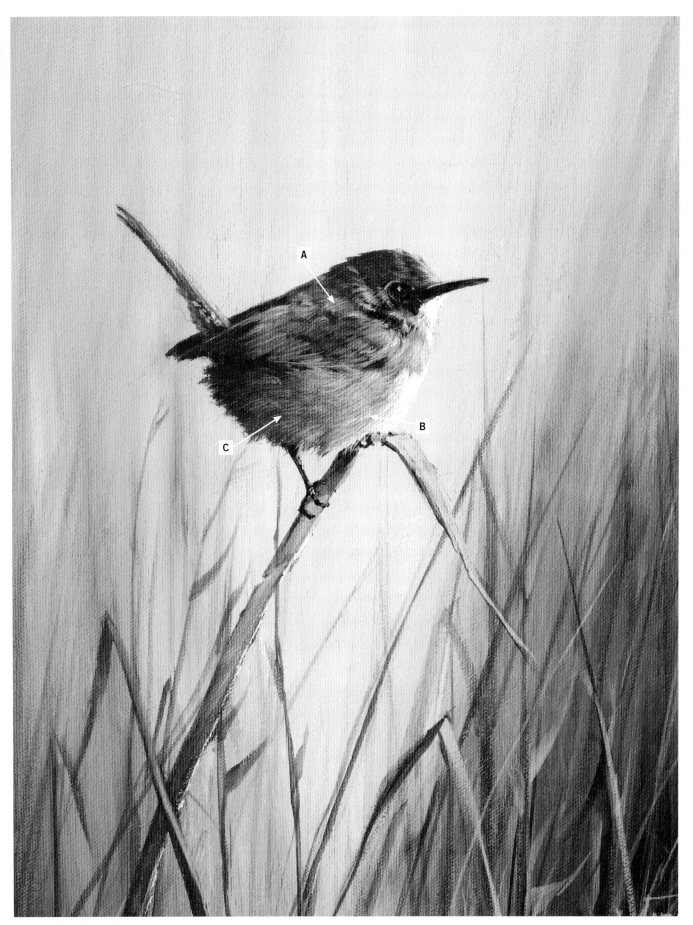

Reddish Brown Toned Animal
A: form highlight; B: accent highlight; C: underpainting tone

Paint Effects

SPLATTERING

Of all the techniques that I have used and taught over the years, one of my favorites is splattering with a toothbrush. You can do amazing things with toothbrush splatters. With a ninty-nine-cent toothbrush, you can create an endless array of effects that a forty-dollar paintbrush can't even come close to creating.

You can create paint splatters in various sizes, depending on your subject and desired effect. It is all determined by the amount of water you mix with the paint, your distance from the canvas, the angle of the toothbrush, the amount of paint on the brush and the stiffness of the bristles. (I once made a mist so fine that it looked like an airbrush had been used!)

Here are just a few of the effects that you can create with the splatter technique:

- snowflakes
- sand
- mist
- fog
- pebbles
- details in wood
- rain drops
- dew drops
- flowers

So, grab a scrap of canvas and a couple of toothbrushes. Practice, practice, practice until you become proficient. You do not want to risk messing up your painting with a bunch of rogue splatters.

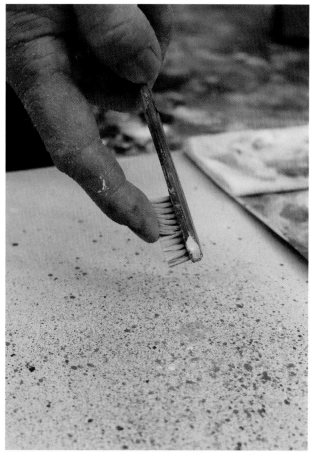

Always Position Bristles Downward for Splattering
Make sure you position the toothbrush properly. Use your forefinger with the brush facing down, toward the canvas. Do not use your thumb with the brush facing up or you will splatter your face.

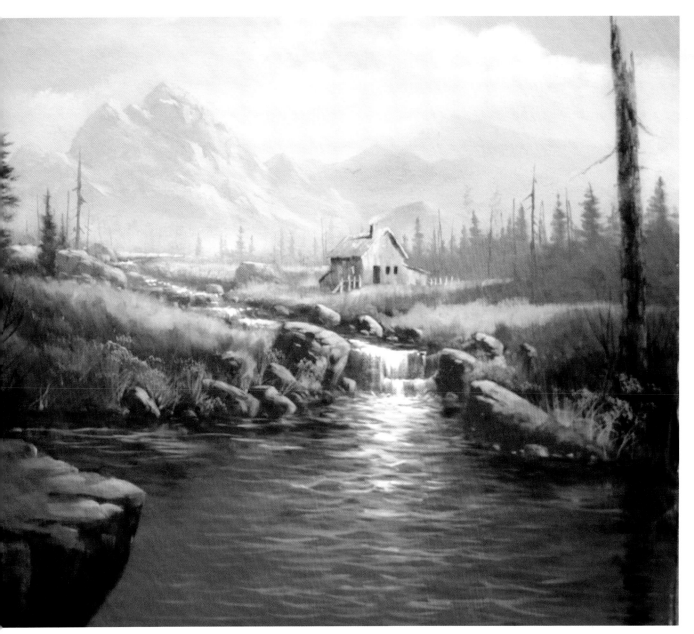

Oil Over Acrylic
This painting is an example of an acrylic underpainting with an oil overpainting. It was completed in about half the time it would have taken to complete using traditional oil techniques. Yet it maintains the same quality as an oil piece. Give it a try—you might like it!

PAINTING OIL OVER ACRYLIC

It may surprise you to learn that some artists use oils on top of acrylics in their paintings. But for many artists who use this technique, including myself at times, it's a real time saver. I love to do a beautiful oil painting, but in my early career I didn't do many because of the long drying time between layers of oil. With this technique, however, you can block in and underpaint the main components of the painting and work out color, composition, design, perspective and other technical issues with acrylic. Because of the quick drying time for acrylics, you can paint right on top of the acrylic underpainting with oil almost immediately rather than having to wait several days for it to dry.

 Tip Although you can layer oil paint on top of acrylic, this process will not work the other way around. This is mainly because of the way the binders in the pigments attach to the surface they're applied to. The acrylic binders will not adhere to an oil surface very well, creating a risk that the paint will peel off over time.

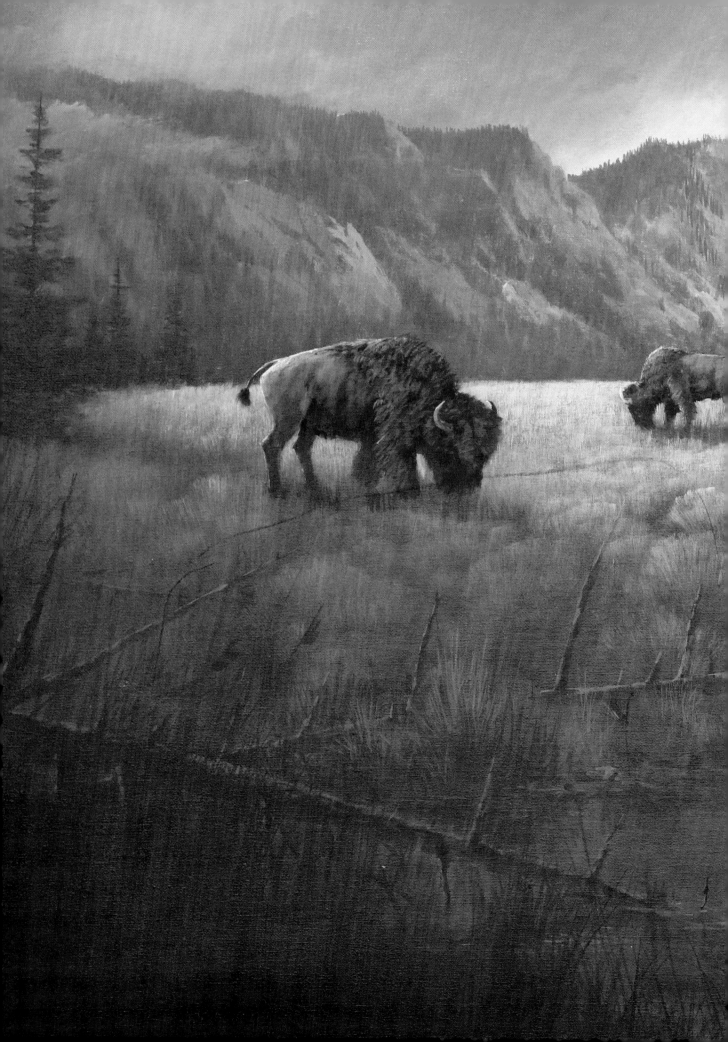

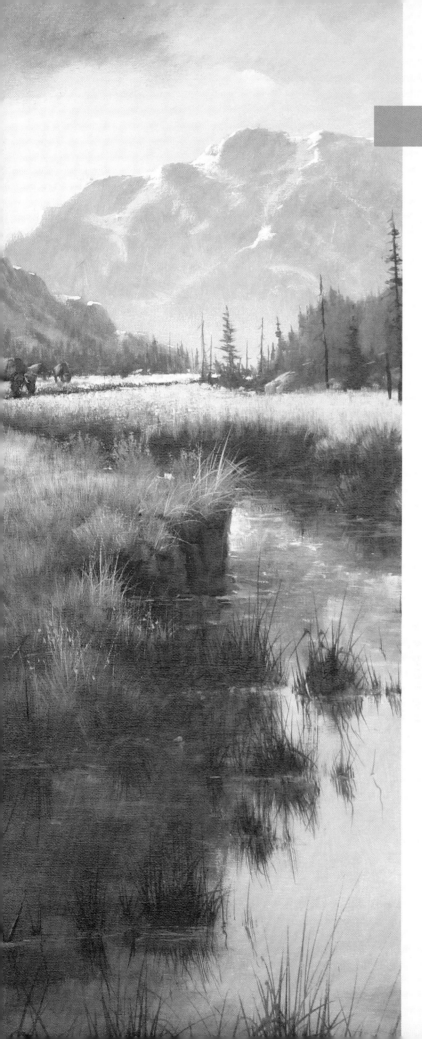

Scenery

If you're an artist, the region where you choose to live and the type of surroundings that engulf your world greatly influence what you paint. Whether it be shrimp boats along the Gulf coast, giant cacti in the desert, towering mountains of the high-country or the endless expanse of the oceans, different types of scenery directly influence an artist's work. For example, I grew up in the Midwest, and for many years my art reflected vast prairies and grasslands, rolling hills, stormy skies, a wide variety of trees and vegetation and a vast array of wildlife.

There is an old saying: An artist's best work directly reflects what they are surrounded by and what they love. So, no matter where you live or what your surroundings consist of, paint familiar scenery and things that you love.

The paintings in this chapter will help you develop your skills and challenge all your artistic abilities. Have fun!

Buffalo Shores
Acrylic on canvas
36" × 24" (91cm × 61cm)

49

Paint a Waterfall Scene

YELLOWSTONE FALLS

This scene is the exact same location where Thomas Moran painted his version of *Yellowstone Falls* in his *Grand Canyon of Yellowstone Falls* series. For a landscape artist, there are few things more exciting than painting a beautiful, natural, free-flowing waterfall. Waterfalls are romantic, emotional, inspiring and just plain fun to paint. They are also one of my favorite subjects to teach because of the wide range of techniques required to create rocks and moving water, not to mention the atmosphere and unique color scheme.

This painting of Tower Fall in Yellowstone National Park, with its powerful cascades, unique rock formations, strong sunlight through mist and the bull elk bugling in the distance, will challenge your skills and inspire your creativity. Do not be afraid to exercise your artistic license; just be careful not to overwork the painting.

Now grab your brushes and follow the steps to paint a majestic waterfall scene.

Materials

SURFACE
16" × 20" (41cm × 51cm) stretched canvas

ACRYLIC PIGMENTS
Burnt Sienna, Burnt Umber, Cadmium Orange, Cadmium Red Light, Cadmium Yellow Light, Dioxazine Purple, Hooker's Green, Ultramarine Blue

BRUSHES
- nos. 2, 4, 6, 10 and 12 bristle flats
- nos. 4 and 6 Dynasty
- no. 4 sable flat
- no. 4 sable round
- no. 4 sable script

OTHER
- soft vine charcoal
- white gesso

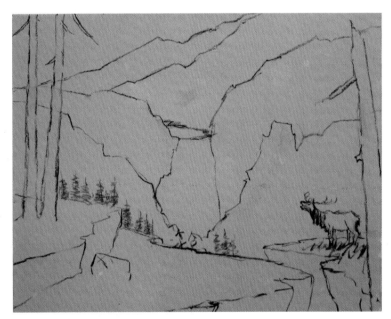

1 Prepare the Canvas and Sketch the Composition

Because of the unique rock formations in this scene, I recommend creating a slight texture when graying or tinting the canvas. This will give the rocks a more distinct three-dimensional effect. Thickly apply a warm gray tint with a no. 10 or no. 12 bristle flat. Use short, choppy crisscross strokes. Do not over-blend, or you will lose the needed texture.

Once dry, roughly sketch in the main components of the scene with soft vine charcoal. Do not spend much time on details—most of the sketch will be lost as you block in color later. If needed, you can re-sketch the various compositional elements as you go.

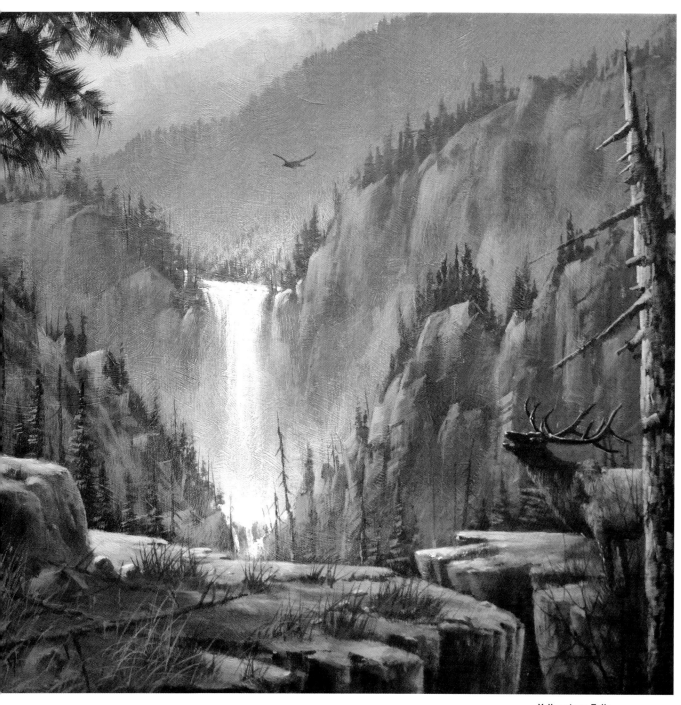

Yellowstone Falls
Acrylic on canvas
16" × 20" (41cm × 51cm)

Tip

Do not use pencil or any other type of hard graphite or charcoal for sketching your composition—they are very difficult to erase.

To erase soft vine charcoal lines or smudges, simply brush gently with a damp paper towel. Any marks will be removed easily.

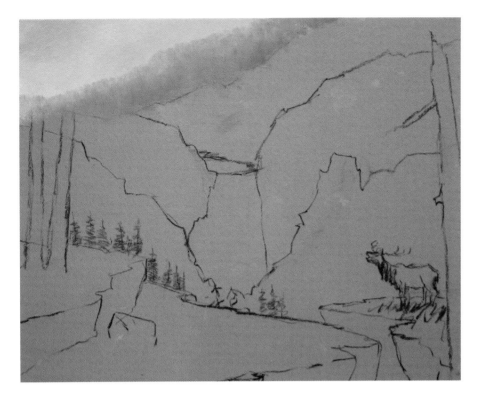

2 Paint the Sky and Most Distant Mountain Range

Use a no. 10 bristle flat to apply a fairly liberal coat of white gesso to the sky area. While it is still wet, add small amounts of Ultramarine Blue and Burnt Sienna, then use crisscross brushstrokes to blend the sky into a light cool gray tone.

Still working while the sky is wet, create a soft gray-green color by mixing white with a touch of Hooker's Green and Dioxazine Purple. This should be only about two values darker than the sky. Begin painting in the distant mountain with a no. 6 bristle flat using short, choppy vertical strokes to create the suggestion of distant trees.

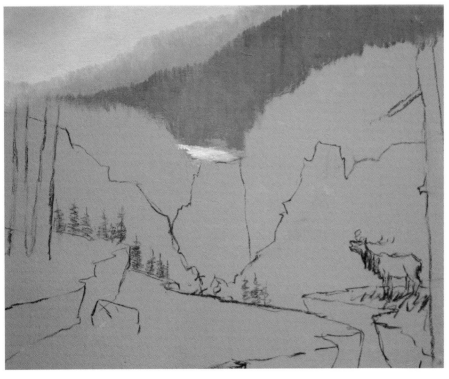

3 Paint the Next Mountain Range

Create a mixture similar to the previous gray-green mixture, but add a little more Hooker's Green and Dioxazine Purple to darken the tone by two values. Be careful not to make this value too dark or too green. Since these are very distant tree-covered mountains, they need to stay on the cool-gray side to create some depth. Use a no. 10 bristle flat to begin stroking in the second mountain range. Once again, use short, choppy vertical strokes to create the suggestion of distant trees.

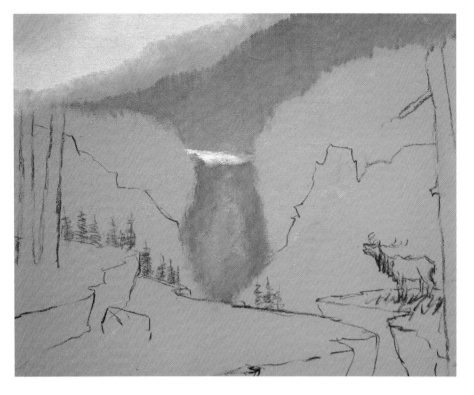

4 Underpaint the Falls and Glaze the Distant Trees

Mix Ultramarine Blue with small amounts of Burnt Sienna, Dioxazine Purple and white to create a mid-tone bluish, mauve-ish gray color. Be careful not to make this too dark. Use a no. 6 bristle flat to paint in the waterfall area with long, scrubby vertical strokes. Make sure that area of canvas is well covered. Wipe the brush clean of most of the paint.

Add a little water to the color mixture to create a semi-glaze, then use a no. 10 bristle flat to wash the glaze over the tree-covered mountain just above the falls. Keep it light and soft to give it a hazy appearance.

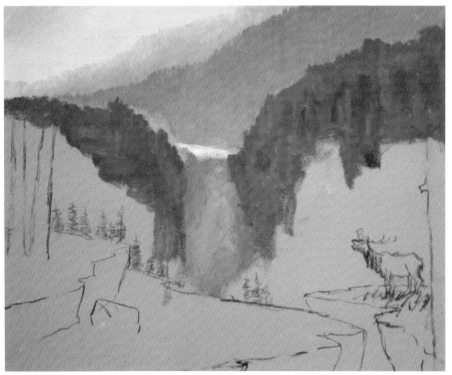

5 Underpaint the Rocks

Underpaint the first layers of the mid-ground rugged rock formations. Mix Burnt Umber and Ultramarine Blue with enough white to create a warm gray tone. This should be about two or three values darker than the closest tree-covered mountain. Use a no. 6 or no. 10 bristle flat and multiple irregular brushstrokes to create a choppy, rugged effect.

If you add touches of white, Burnt Umber and Ultramarine Blue as you go, you can create multiple values of light and dark areas which further suggest rugged rock formations. Keep in mind, though, you are only underpainting at this point, so keep the strokes loose and rough. You will not start adding details until the later stages.

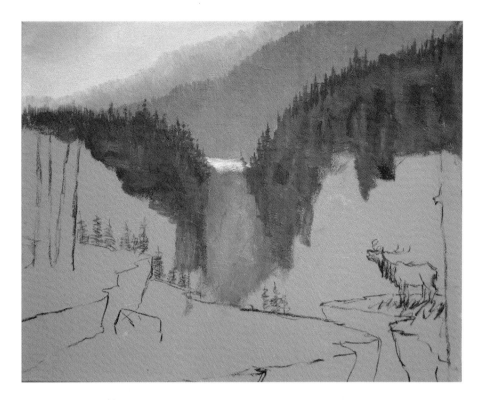

6 Paint the Pine Trees

This is a simple, but very important step. Mix Hooker's Green and a little Dioxazine Purple with just enough white to create a green-gray tone about the same value as the underpainting for the rock formations. Use a no. 2 bristle flat or a no. 4 sable flat (whichever you have the most control with) to paint small pine trees along the ridge of the rock formations. Be sure to create a variety of shapes and heights and to include pockets of negative space to make it look interesting.

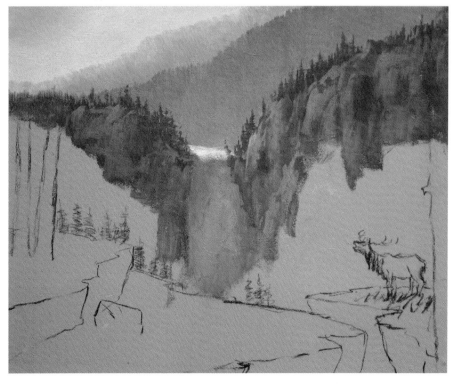

7 Begin Adding Highlights

To highlight the mid-ground rock formations, create a soft warm tone by mixing white with a touch of Cadmium Orange and Ultramarine Blue. Load a small amount onto a no. 4 bristle flat, then add a bit of water to create a very thin glaze. Apply brushstrokes of various lengths, widths and angles to create highlights and interesting pockets of negative space in the various rock formations.

Do not apply your brushstrokes too heavily or thickly, or the highlights will appear far too bright. Vary the pressure with your brush and the amount of glaze to allow some of the background to show through. You will add final highlights and details later.

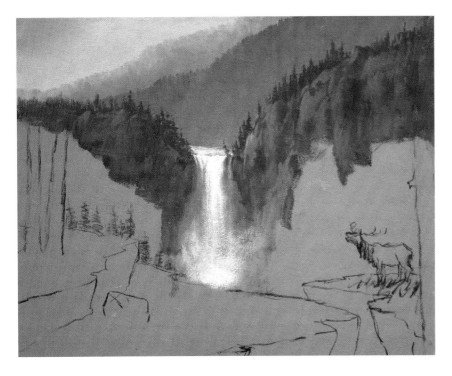

8 Build Up the Waterfall

Evenly load the tip of a no. 6 Dynasty with a thin glaze of white. Use gentle, careful strokes to apply the first layer of under-highlight from the top of the waterfall downward. When the water evaporates out of the white, it will dull slightly. Once it has dried, repeat this step until you achieve the level of brightness you desire for the falls.

Mix a glaze with white and a slight touch of Ultramarine Blue, then scrub in some mist and overspray at the sides and base of the falls with a no. 4 bristle flat. As with the waterfall under-highlights, you may have to apply two or three layers to get the brightness you desire.

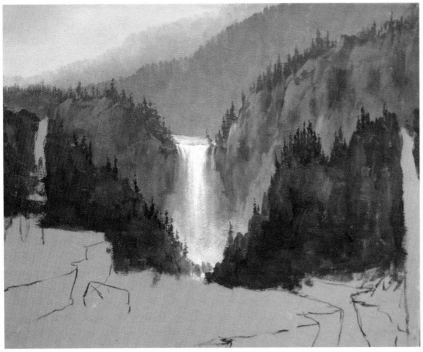

9 Paint the Middle Foreground Rocks

This step is almost identical to step 5. The only difference is that you will be using colors that are about three values darker. At this point, you do not need to pre-mix any color. Just double or triple load a no. 6 bristle flat with Burnt Umber and touches of Ultramarine Blue or Burnt Sienna. Begin mottling these colors together along with touches of white to create various light and dark pockets to suggest rugged rock formations. Use a lot of brushstrokes and thick paint to create texture. Do not over-blend or smooth this area out.

Next, take a bit of that same mixture, add a little Hooker's Green, and dab in the pine trees along the top of the ridges.

Tip Keep in mind that when the water evaporates out of your transparent glazes, it is normal for the color to darken by two or three values. This allows you to apply multiple layers to create soft, bright highlights.

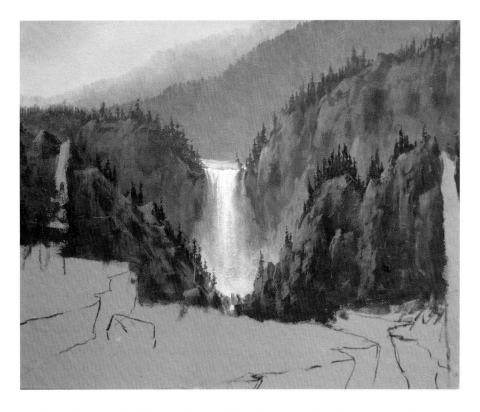

10 Add Highlights to the Middle Foreground

Add soft, warm highlights on the middle foreground rock formations to create the rugged rock effect that the Yellowstone region is known for. Mix white with a small amount of Cadmium Orange and Ultramarine Blue. Slightly thin the mixture with water, then load a very small amount onto a no. 4 bristle flat. Begin applying a variety of long, short, narrow and wide brushstrokes to the rocks in the middle foreground.

It is very important to create interesting pockets of negative space, so make sure you don't cover up all of the underpainting. Keep in mind that it is the darker shadows that add dimension to the rock formations.

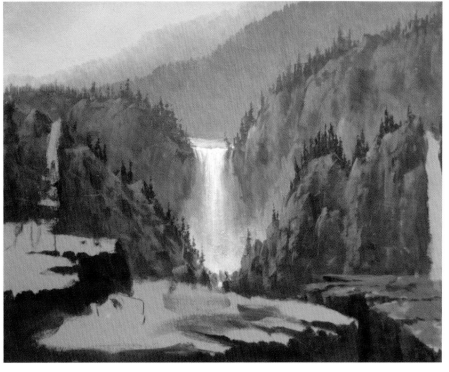

11 Underpaint the Foreground Cliffs

Triple load a no. 6 bristle flat with Burnt Umber, Ultramarine Blue and a little Dioxazine Purple. Apply these darker colors to the front side of all of the foreground cliffs. Drag the color into the top of the rock where the cracks and crevices will go. Make sure to leave some brushstrokes showing. Add small amounts of white as you go to create multiple values of this darker tone. Remember, this is still only the underpainting stage. You will add final details and highlights at the end of the painting.

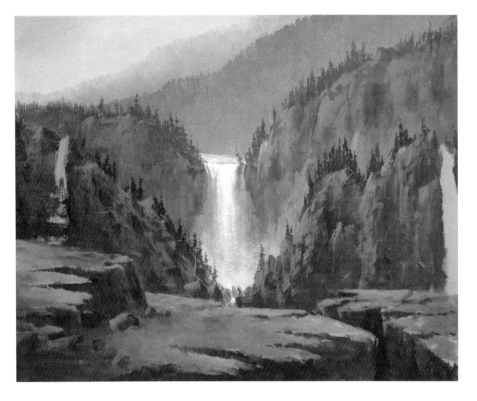

12 Add Texture

This part of the process is called *capping*. Mix white with a touch of Burnt Umber and Cadmium Orange. Thin it to a creamy consistency, and load a small amount onto the tip of a no. 4 or no. 6 bristle flat. Begin scrubbing it across the top of each cliff. Use a variety of short, long and smudgy strokes to create a little texture and choppiness. Be sure not to over-blend. Also, do not be afraid to change the hue and value, if necessary.

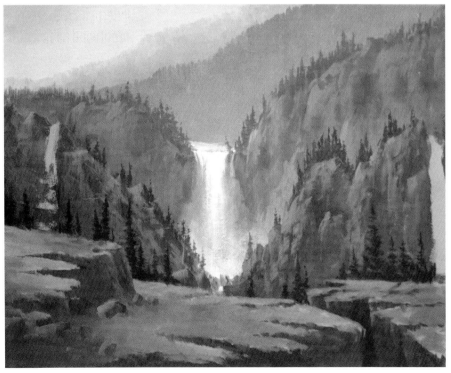

13 Paint More Pine Trees

Now it's time to add in the larger, taller pine trees just behind the cliff rocks. Start with a very creamy mixture of Hooker's Green and a little Dioxazine Purple. This will create a rich, deep dark green color. Load the tip of a no. 2 or no. 4 bristle flat and begin dabbing in the taller trees just behind the cliff rock formations. The most important thing to remember here is to have a good variety of shapes and sizes to create interesting pockets of negative space.

These trees will help pull the viewer's eye into the middle foreground of the painting, so it's important not to let them overpower the composition. Just go for a nice arrangement with good flow.

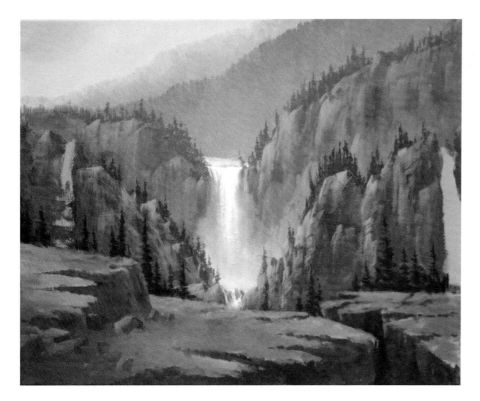

14 Add Highlights and Details to the Background Rocks

Mix white with a touch of Cadmium Orange, Cadmium Red Light and Cadmium Yellow Light. Load a small amount onto a no. 6 Dynasty and begin gently highlighting the background rock formations. Use a feather-light stroke and be careful not to lose the darker underpainting tones.

Feel free to experiment with this color mixture by adding more Cadmium Orange, Cadmium Red Light or Cadmium Yellow Light to create other hues. (Yellow-gold tones are most effective for highlighting these rocks.)

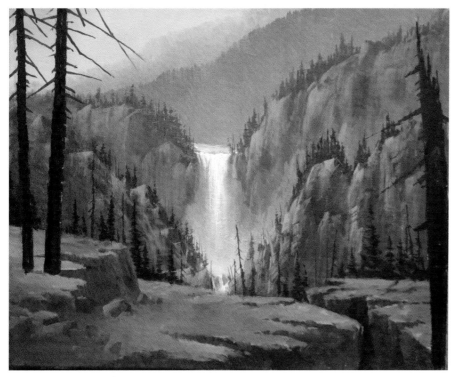

15 Begin Painting the Foreground Trees

Begin painting in all of the pine tree stumps and limbs in the foreground. Use either a no. 4 sable round or a no. 4 sable script for the more distant stumps. For the larger trunks, use a no. 6 Dynasty. Start with a mix of Burnt Umber and Ultramarine Blue, plus a touch of white, to create an almost black tone. Use this for the foreground trees, adding white to adjust the value according to where the trees are located. If you are using a no. 4 sable script, thin the mixture to an ink-like consistency. This helps the paint flow more easily, which will help you create better forms.

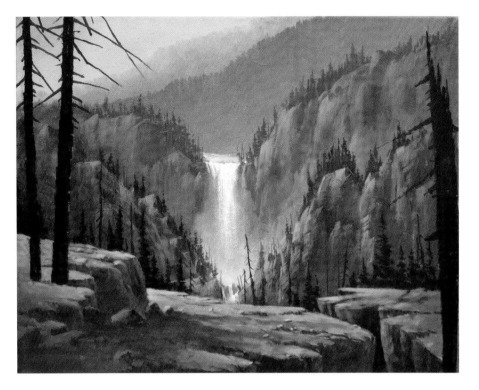

16 Paint the Foreground Highlights

Create a soft, light, warm gray tone by mixing white with a little Cadmium Orange and Ultramarine Blue. Use a no. 4 or no. 6 bristle flat to begin scrubbing in highlights on the foreground rocks and cliffs with short, choppy horizontal strokes. Keep the strokes rough and loose. Vary the lengths to create the rugged, rough texture of rock. Use a no. 2 bristle flat to dab in a few small dark rock shapes scattered throughout the top of the cliff, then highlight them with the original color mixture you used for the top of the cliff.

Experiment with dark and light areas across the top of the cliff so it is more interesting in form and value. For smaller rocks, use a no. 4 sable flat or round (whichever gives you more control).

17 Add the Foreground Details

Once the cliff has been formed with its highlights, you can have fun exercising your artistic license by creating additional details. Mix Burnt Umber and a touch of Ultramarine Blue with Dioxazine Purple. Add a small amount of white to keep the mixture from becoming too dark. Use a no. 4 sable script to paint weeds and small limbs and a no. 4 sable round or flat for larger sticks and additional rocks, cracks and crevices in the cliffs. Keep taller weeds in the immediate foreground and create a variety of lengths and shapes. It is important not to make this area too busy. Just create nice clumps of grasses with good flow and interesting pockets of negative space.

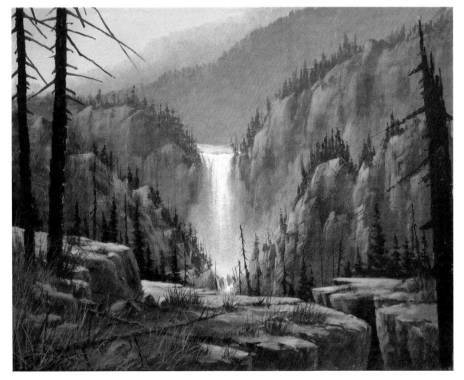

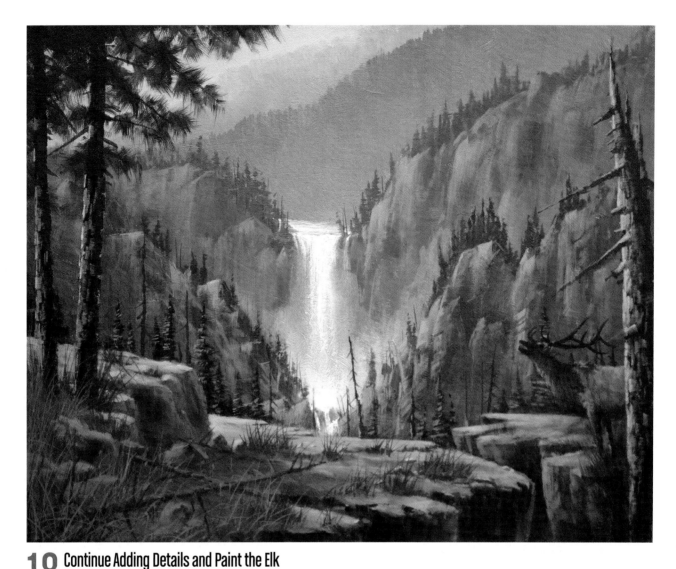

18 Continue Adding Details and Paint the Elk

To paint details like the pine boughs in the upper left corner, create a creamy mixture of roughly ¾ part Hooker's Green and ¼ part Dioxazine Purple. With a no. 4 or no. 6 Dynasty, begin skimming the surface of the tooth of the canvas with very light, short strokes in all different directions. It takes practice to make them look like the pine needles, so do not give up. Eventually you will get it.

For the bark on the large trees, mix white with a touch of Cadmium Yellow Light and Burnt Sienna. This should create a soft, warm gold color. Thin the mixture slightly, then load a small amount onto a no. 6 Dynasty and use short, choppy horizontal strokes up and down the left side of all the large trees. Gradually lighten your pressure as you move toward the center of the tree to create a soft, faded ending. Be sure not to cover up all of your underpainting— leave small chunky pockets of negative space to create the suggestion of rough bark. Do not be afraid to repeat this step a couple

more times to make the highlights brighter. Just be careful not to lose those nice pockets of negative space, or the bark will appear too blended and smooth.

Smudge a few brighter highlights throughout the painting on all of the rock formations and the foreground cliffs with the same color mixture you used for the bark.

Use soft vine charcoal to make a very light rough, loose sketch of an elk. No detail is needed. Mix a medium-dark brown-gray tone with Burnt Umber and a little Ultramarine Blue plus white. Underpaint the elk's head and neck with a no. 2 bristle flat. Make sure the edges are soft. Paint in the antlers and legs with a no. 4 sable round. Lighten the mixture by about two values and then underpaint the rest of the elk's body. Do not paint the body with a hard outlined edge. Pull your strokes inward from the edge of the body to make the edges soft and slightly irregular.

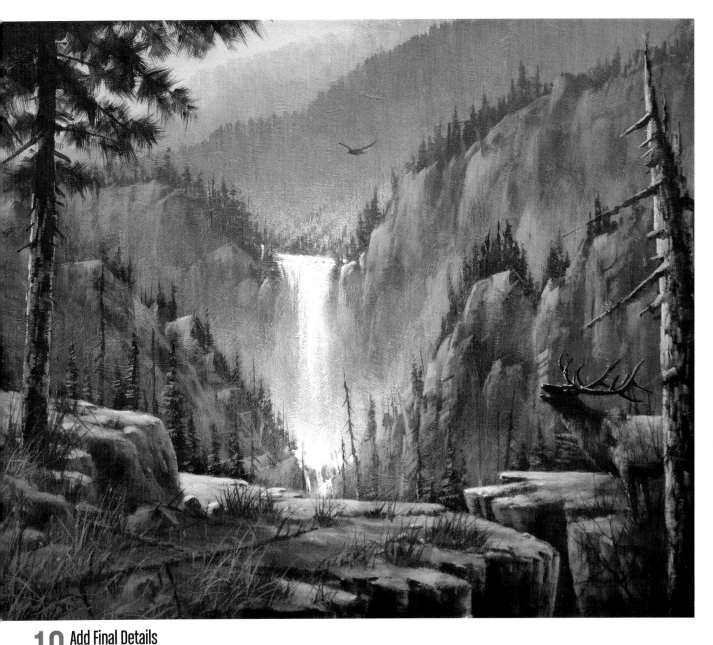

19 Add Final Details

This is what I like to call *the beauty step!* Now is the time to have fun adding all of the final details, highlights and hot spots to give the painting life and make it pop. Start by using white to paint the final highlights on the waterfall.

Since this painting is somewhat monochromatic, it needs additional highlighting. Mix white with a touch of Cadmium Orange and Cadmium Yellow Light to make a warm gold color. You'll have to change brushes depending on which area you're highlighting. For instance, if you need a thin accent line or highlight on the edge of the tree trunks or the edge of the elk antlers, use a sable script.

If you want to add some bright spots, like on the rock formations or cliff, use a small bristle flat to smudge in some brighter color throughout the painting.

Finally, paint reflected highlights on the back side of the large trees. Mix Ultramarine Blue, Dioxazine Purple and enough white to create a medium-value cool highlight. Use a no. 2 bristle flat to smudge a small amount of this color up and down the right side of the tree trunks. Keep it soft and subtle, and do not go too far into the center of the trees.

Paint a Swamp Scene

A SWAMPY PARADISE

The swamp is an amazing place. Swamps, with their vast array of wild-life and vegetation, provide multiple opportunities for artists to unleash their creative license in composing paintings with unique atmosphere, beautiful lighting and stunning color schemes.

In this particular painting demonstration, we will focus on atmosphere. The late evening back-lit sun glow and the silhouette of the giant cypress trees with their hanging moss create a terrific artistic challenge. The reflections in the water and the contrast of the heron and egret against the rich dark tones make this painting a real eye-catcher.

Materials

SURFACE
16" × 20" (41cm × 51cm) stretched canvas

ACRYLIC PIGMENTS
Burnt Sienna, Burnt Umber, Cadmium Orange, Cadmium Yellow Light, Dioxazine Purple, Hooker's Green, Ultramarine Blue

BRUSHES
- nos. 2, 4, 6, 10 and 12 bristle flats
- nos. 2, 4 and 6 Dynasty
- no. 4 sable flat
- no. 4 sable round
- no. 4 sable script

OTHER
- soft vine charcoal
- white Conté pencil
- white gesso

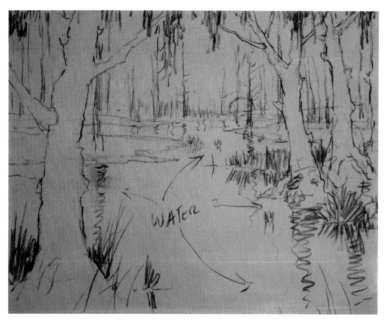

1 Prepare the Canvas and Sketch the Composition

Apply a warm gray tint to the canvas with a no. 12 bristle flat. Once dry, make a rough, simple sketch of the main landmasses and objects, specifically the larger trees, with soft vine charcoal. Don't worry about sketching in the heron or egret at this point. The composition may change some, so it's best to wait to place them until after you have painted the trees. You can take a photo of the sketch or make a separate sketch to document the composition if you like.

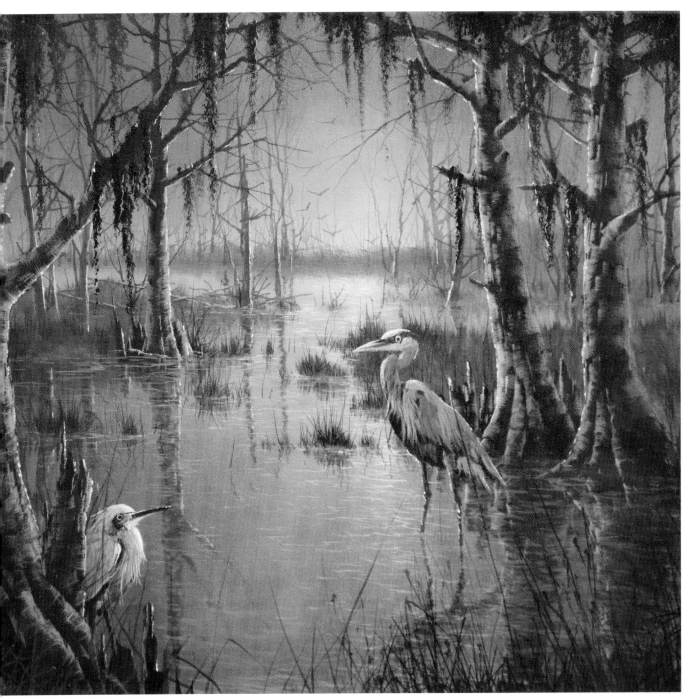

A Swampy Paradise
Acrylic on canvas
16" × 20" (41cm × 51cm)

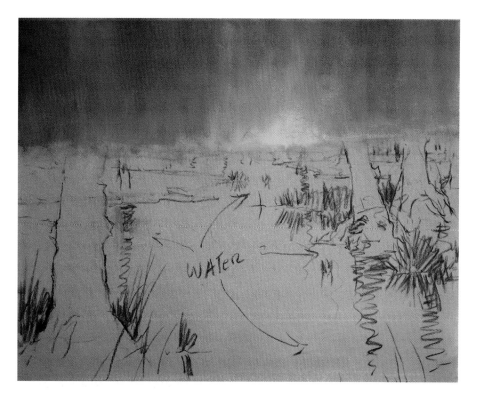

2 Underpaint the Sky

Use a no. 10 bristle flat to apply equal amounts of Cadmium Yellow Light and Cadmium Orange with a touch of white across the horizon about halfway up the sky. While the paint is still wet, apply Ultramarine Blue with a touch of Dioxazine Purple and Burnt Sienna across the top of the sky. Blend all these colors together using long, vertical strokes. Be careful not to lose the warm orange glow across the horizon, specifically the spot to the right of center.

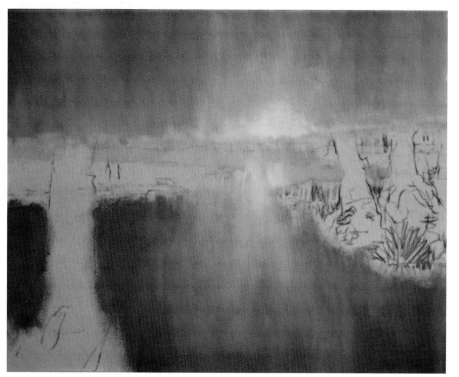

3 Underpaint the Water

To underpaint the water, repeat the same process you used for the sky. The only difference here is that you have a larger area to deal with, so you'll need to move quickly and use long strokes. Consider switching to a no. 12 bristle flat for this step. It will cover more area and save you a little time.

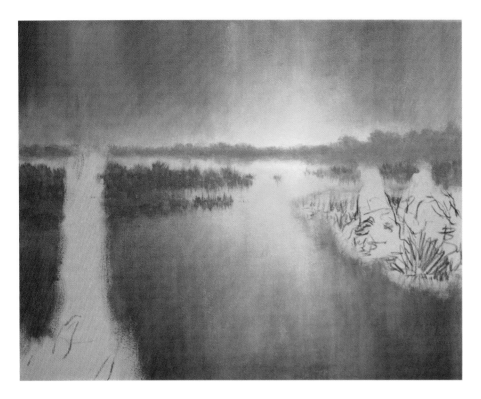

4 Brighten the Sky and Water

Mix equal amounts of Cadmium Orange and Cadmium Yellow Light with a slight touch of white to make it opaque. With a no. 6 bristle flat, apply a small amount of this color at the center of the glow in the sky area. Use a dry-brush technique with a circular motion, blending slowly outward until you have a soft but bright glow. Do to the same for the water area. Do not be afraid to repeat this step more than once to achieve the brightness you desire.

Next, paint the middle-ground islands on the left and right side of the main body of water, and the first layer of trees along the horizon. Create a mixture of Dioxazine Purple with touches of Ultramarine Blue and Cadmium Orange. Add just enough white to create a medium value. Use a no. 4 bristle flat to paint in the trees along the horizon with a downward stroke and a dry-brush technique. Then darken the color by about one value and underpaint the grassy islands using upward brushstrokes.

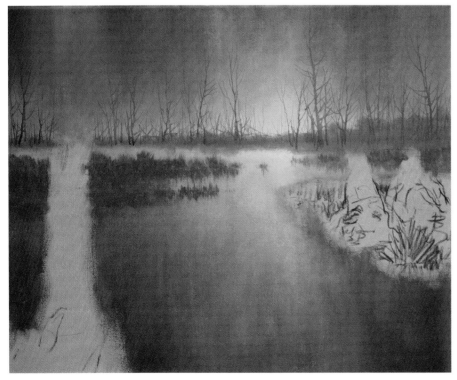

5 Paint the Small Distant Trees

Mix Dioxazine Purple with a touch of Burnt Umber and white to create a value that is about two values darker than the horizon sky color. Thin it to an ink-like consistency. Fully load a no. 4 sable script by rolling it in the mixture until it forms a sharp point. Paint in a collection of delicate, distant trees all along the horizon. Make sure you create a variety of shapes, sizes and heights, and remember to include interesting pockets of negative space.

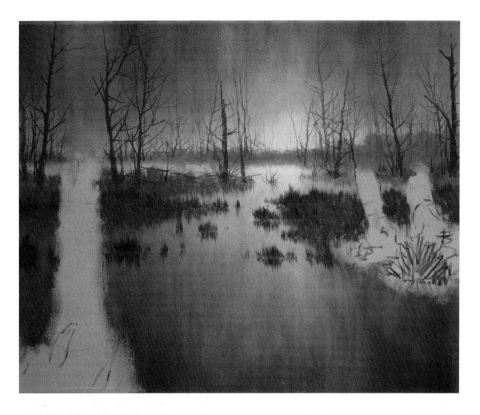

6 Paint the Grass and Re-Sketch the Large Trees

Take the same color mixture you used for the distant trees and darken it by at least one value. Then, add a little more Dioxazine Purple and Burnt Umber. Make it a creamy consistency. Block in the remaining clumps of grass and brush in the middle foreground section of the water with a no. 4 or no. 6 bristle flat. As you pull upward to create the clumps, you'll need to pull downward as well at the bottom of the clumps in order to create the reflections.

This would be a good time to re-sketch the larger trees to be sure that your composition, proportions, negative space, shape and size fit your particular painting. Use either soft-vine charcoal or a white Conté pencil for this. Do not worry about all the small limbs; just capture the main trunks and larger limbs.

7 Paint the Foreground Trees

Mix a dark but warm blackish-brown color from 1 part Burnt Umber, ¼ part Ultramarine Blue and ¼ part Dioxazine Purple. Block in the larger trees with a no. 6 bristle flat. Then, lighten the mixture by about one value and use a no. 2 or no. 4 bristle flat to underpaint the three middle-ground trees.

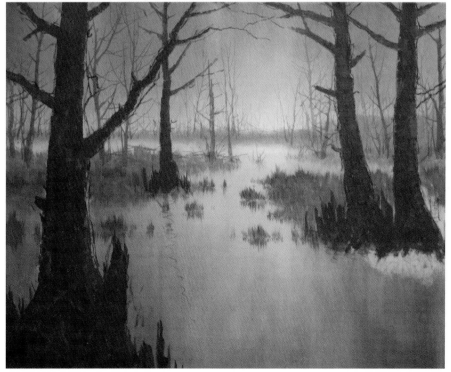

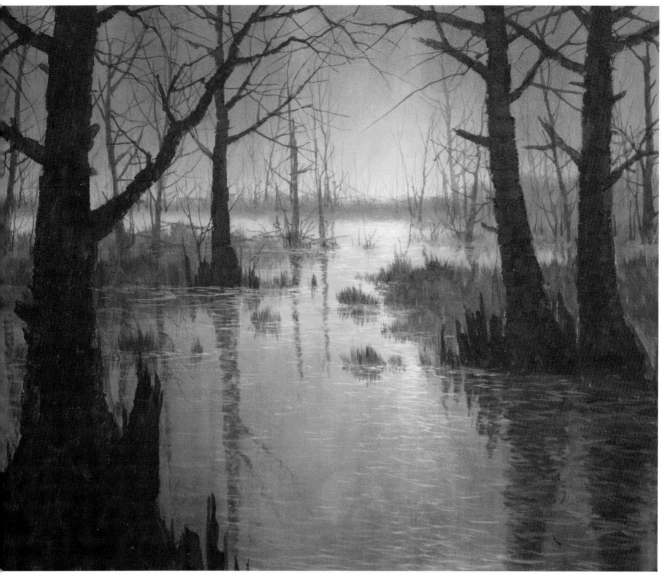

8 Add Reflections and Paint the Ripples

Paint in the tree reflections with a no. 4 sable flat and a mixture of 1 part Burnt Umber and ¼ part Ultramarine Blue.

To add the first layer of water ripples, thin a small amount of white and load it on the end of a no. 4 sable flat. Use short, horizontal strokes in a zigzag pattern to suggest a rippled effect on the water and across the reflections.

Next, paint in all the additional tree limbs with a no. 4 sable script and the same dark mixture you used for the tree trunks in step 7. Try to create an interesting canopy of overlapping limbs.

Add some minor ripples and glazes to soften the water and make it appear wetter. Create a cool medium gray tone by mixing white with a touch of Burnt Umber and Ultramarine Blue. Thin it to nearly a glaze-like consistency and load the chisel edge of a no. 2 Dynasty with a small amount. Position the brush horizontal to the canvas and gently paint in the next layer of ripples over the darker areas of the water. Keep them fairly flat so the water does not become too choppy.

Continue using this same technique and Cadmium Yellow Light with a touch of white to paint in the brighter ripples toward the center of the water.

9 Highlight the Tree Trunks

Mix white with a touch of Cadmium Orange. Make it a creamy consistency. Load the chisel tip of a no. 4 Dynasty and carefully begin dabbing the bright color on the left side of the tree trunks that are located to the right of the lightsource and on the right side of the tree trunks to the left of the lightsource. These trees have wide bottoms with many exposed roots, so use foreshortening to separate them.

A foreshortened limb or root will appear to protrude forward or recede back, as opposed to just sticking out from the side of the tree trunk. Use a no. 4 or no. 6 Dynasty to make C-shaped brushstrokes from the top of the limb to the bottom. Create a series of these strokes coming forward and overlapping each other until you have the length and shape you want.

10 Paint the Hanging Moss

Mix equal parts Hooker's Green and Dioxazine Purple. This will create a dark, rich, blackish green color. Thin it to a creamy consistency, then load the tip of a no. 2 bristle flat with a fairly thick amount. Position the brush vertically to the canvas, dab the color at the top of each limb and work your way downward. Re-load the brush often to make sure the moss has a texture to it.

Tip

If you happen to over-highlight any area of your painting, simply desaturate the highlights and begin again. There is no shame in starting over—several times, if necessary. We all have to do it from time to time.

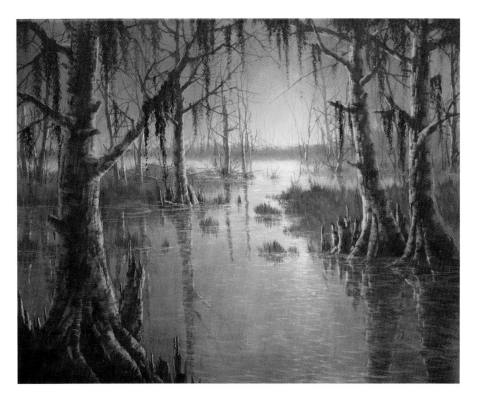

11 Add Reflected Highlights

Paint reflected highlights on the back side of the larger trees and larger limbs. Mix Dioxazine Purple with just enough white to create a medium-dark purple tone. It is important that this value is not too white. Load a tiny amount on the tip of a no. 4 Dynasty. Hold the tip vertically to the canvas and carefully drag the brush across the shadowed side of the trunks with a dry-brush technique. Do not drag too far across—go just far enough to create a soft, cool highlight.

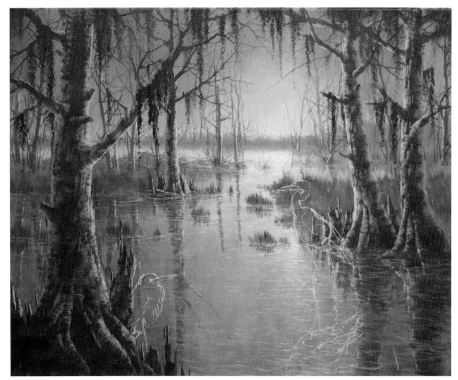

12 Sketch the Birds

With white Conté pencil, lightly but accurately sketch in the shape of a great blue heron and a white egret. You may have to experiment some with the location, shape and proportion of both birds to be absolutely sure they fit correctly into your composition.

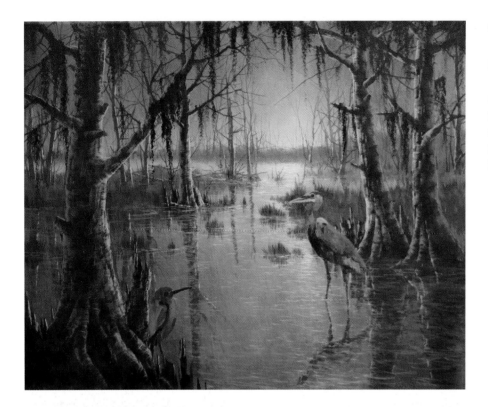

13 Underpaint the Birds

Underpaint both birds with a basic gray. Create a mix for this from 1 part Ultramarine Blue and ¼ part Burnt Sienna with just enough white to create a medium-dark tone. Use a no. 4 sable flat and a no. 4 sable round to block in all the dark and light areas.

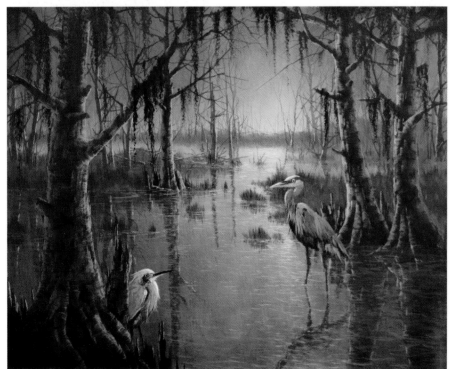

14 Enhance the Details and Highlights

Continue using your no. 4 sable flat and round brushes to enhance the details and highlights. Simply make the whites whiter. Just be sure not to use pure white. I suggest tinting it with a little Cadmium Orange. Add as much detail as you are comfortable with, but be careful not to over-highlight because these birds are somewhat in shadow. Once you are satisfied with the birds, we will move on to the next step to finish up the final details and highlights.

15 Make Final Adjustments and Additions

Now it's time to add additional details, highlights and, in this particular painting, a very strong golden silver lining on the edge of the tree trunks, birds and hanging moss. At this point, you'll also want to paint in the final weeds, twiggy branches and any other details you are comfortable with.

For the golden silver lining, mix white with touches of Cadmium Yellow Light and Cadmium Orange. Load the tip of a no. 4 sable script and paint a very thin, broken line along the edge of the larger trees, branches, birds and moss. Then finish the foreground details, weeds and distant birds.

Paint a Desert Scene

WONDERS OF THE SOUTHWEST

If you have never been to the desert, you might picture it as a dry, lifeless, colorless place. However, I promise you, one trip to the desert and your appreciation for this unique landscape will change very quickly. It may be dry and hot, but it's far from lifeless.

I was amazed the first time I saw the desert. My breath was taken away by the immense beauty—the endless array of color, the countless flowers from poppies to verbena that dotted the landscape—not to mention the rugged beauty of the timeless mountain ranges, huge boulders and dry riverbed washes. And then there is the wildlife to top it all off.

The desert in this painting demonstration is just begging you to pick up your brushes and document its wonders.

1 Prepare the Canvas and Sketch the Composition

Use a hake brush to apply a warm gray tint to the canvas. Once dry, create a rough sketch of the main landmasses and rock formations with soft vine charcoal. Don't worry about making a very detailed sketch. Because there is large number of rock formations in this scene, the composition will change some as the painting develops.

Materials

SURFACE
16" × 20" (41cm × 51cm) stretched canvas

ACRYLIC PIGMENTS
Burnt Sienna, Burnt Umber, Cadmium Orange, Cadmium Red Light, Cadmium Yellow Light, Dioxazine Purple, Hooker's Green, Ultramarine Blue, Vivid Lime Green

BRUSHES
- 2" (51mm) hake
- nos. 2, 4 and 6 bristle flats
- nos. 2, 4 and 6 Dynasty
- no. 4 sable flat
- no. 4 sable round

OTHER
- medium or firm toothbrush
- soft vine charcoal
- white gesso

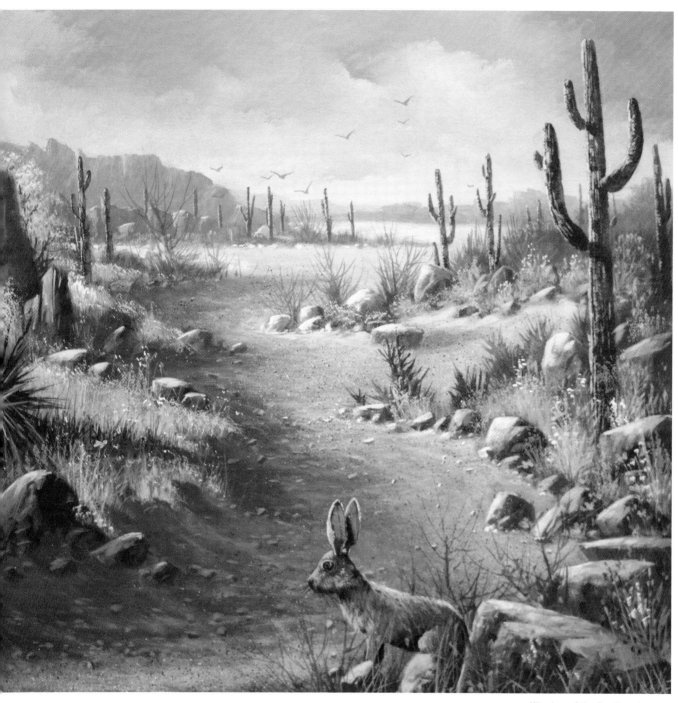

Wonders of the Southwest
Acrylic on canvas
16" × 20" (41cm × 51cm)

Tip If you prefer to follow a sketch as you go along, you can create a more detailed sketch on a sketch pad for reference.

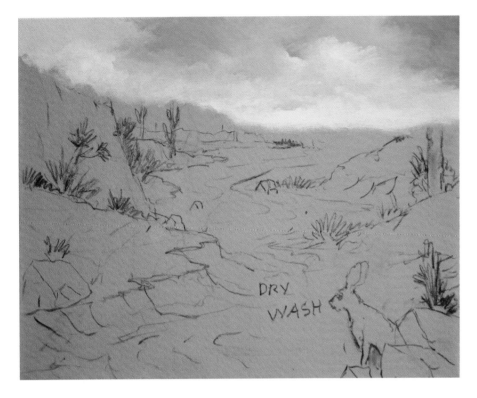

2 Paint the Sky

Paint in the sky with a no. 6 bristle flat and a combination of soft, cool tones. There is no need to pre-mix any colors because this is a wet-in-wet technique—you will do all your mixing right on the canvas. Start in the upper-right corner and scrub on a small amount of gesso. Work your way down a few inches, then begin adding touches of Ultramarine Blue, Dioxazine Purple and Burnt Sienna. Scumble them together to create multiple values, colors and tones. Make sure you keep the sky fairly light.

Add just enough white into the mixes to create soft, wispy clouds. As you continue blending down toward the horizon, add a touch of Cadmium Red Light to create a subtle pink tint.

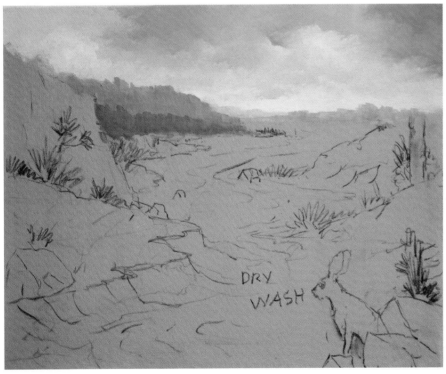

3 Paint the Distant Mountains

Paint in the first layers of the distant mountains. You want these to be about two values darker than the sky. Mix white with touches of Ultramarine Blue and Burnt Sienna to get a soft, cool, bluish-gray color. Then, add a very small amount of Dioxazine Purple to give it a slightly purple cast. Load a small amount across the chisel tip of a no. 4 Dynasty and start blocking in the distant mountains. Use short, downward strokes to create unique shapes, forms and pockets of negative space. Be sure to double-check the value so that it does not become too dark.

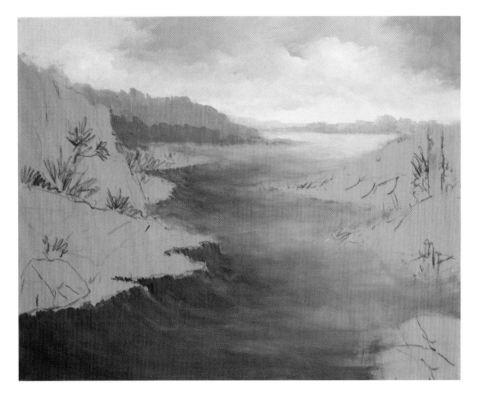

4 Underpaint the Dry Washbed

Starting in the background and working your way forward, begin scrubbing in some white in long strokes with a no. 4 or no. 6 bristle flat. While it is still wet, add touches of Cadmium Orange and Dioxazine Purple into the white to create a soft warm tone. Continue working forward and gradually begin darkening the wash bed by adding some more Dioxazine Purple, Burnt Umber and touches of Ultramarine Blue for the darker pockets. The left side of the wash bed should be darker than the right side, so be sure to blend carefully to create a gradual transition.

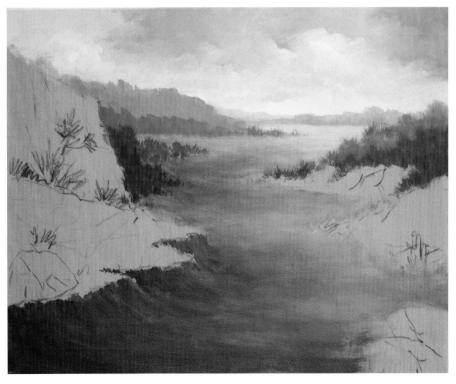

5 Underpaint the Mid-Ground Bushes

With a no. 4 bristle flat, mix Hooker's Green and a touch of Dioxazine Purple with white to create a medium-dark greenish-gray tone. Make it nice and creamy. Then, take your brush and pull upward to create the shape of bushes and clumps of grass. Remember, this is only the underpainting—you will highlight and detail these areas in a later step.

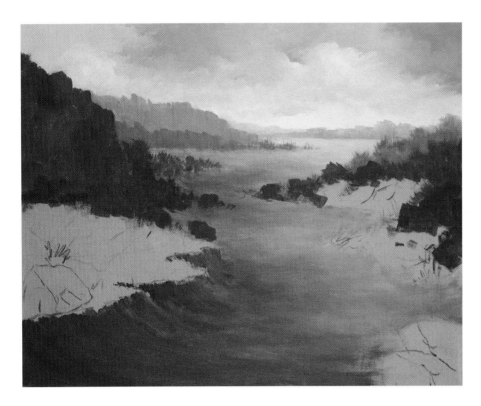

6 Underpaint the Large Rock Formation

Underpaint the large rock formation to the left of the wash bed and some of the smaller rocks and boulders along its edge with Burnt Sienna, Ultramarine Blue, Dioxazine Purple, Cadmium Red Light and a small amount of white to create multiple value and tonal changes. Use a no. 4 or no. 6 Dynasty and leave plenty of visible brushstrokes to create a mottled effect. The end result should be a medium-dark value with an overtone of warm brownish-purple. You will have to experiment a bit to achieve the proper value and effect.

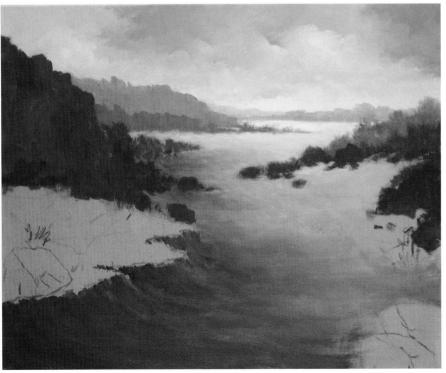

7 Highlight the Background

Highlight the background wash up to about midway. Mix white with a touch of Cadmium Orange. If you want this tone to be more golden, then add a touch of Cadmium Yellow Light. Make sure the mixture is very creamy. Load a no. 4 bristle flat and begin scrubbing in the warm tone with long, horizontal strokes. Be sure to paint in the area on the right side beneath the bush and small rocks.

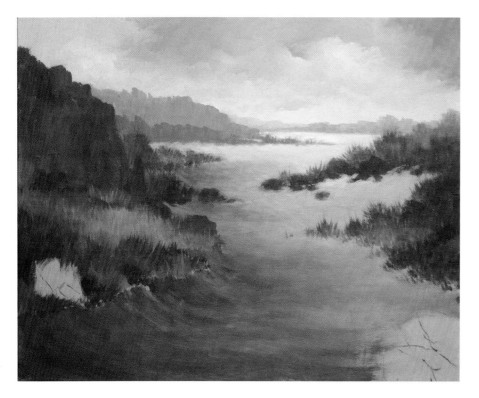

8 Underpaint the Remaining Grassy Areas

Underpaint the rest of the grassy and brushy areas with a no. 4 or no. 6 bristle flat. Begin painting in the brush with upward strokes using a combination of warm mustard and olive green tones. The basic mixture for this is 1 part Hooker's Green with about ¼ part Burnt Sienna. You can also add Cadmium Orange if you wish. Use this value and color for the darker areas. Then, add Cadmium Yellow Light for the lighter values and colors to create contrast and add some dimensional form to the brush.

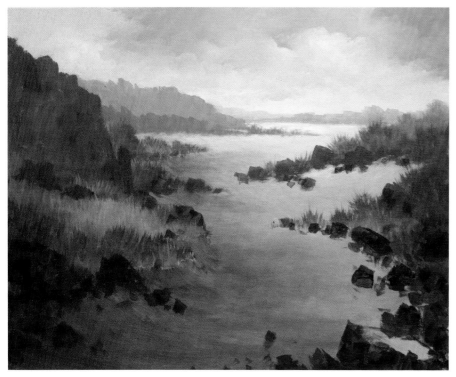

9 Rearrange the Rocks

Step back and evaluate your progress. If necessary, re-arrange the rock formations that you underpainted in step 6. Then, underpaint the remaining rocks and boulders in the middle and foreground.

Create a charcoal gray base color by mixing 1 part Ultramarine Blue, ¼ Burnt Sienna and just enough white to create a medium-dark value. Use a no. 2 or no. 4 Dynasty to finish blocking in the other rocks and boulders, and spend a little time adjusting the previously painted ones until you are happy with your location, proportion, shapes and negative space.

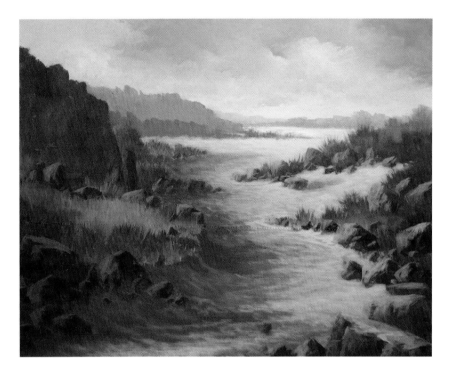

10 Highlight the Rocks and Sand

Mix white with touches of Cadmium Orange and Ultramarine Blue. This needs to be a soft, warm, neutral tone just light enough to create the form of each rock. Thin it to a creamy consistency, then use a no. 4 or no. 6 Dynasty to paint the first layers of highlights on the rocks. It does not take much paint to do this, so load only small amounts on your brush.

Switch to a no. 4 bristle flat and add a little more white plus a touch of Cadmium Orange to brighten the mixture. Thin it until it is almost a glaze, then highlight the sand by swirling in the ripples. Use elliptical strokes, which will help make the wash appear flat. Repeat this step two or three times until you achieve the brightness you want.

11 Splatter the Sand

Create a tan tone by mixing white with a touch of Burnt Umber. Thin it to an almost watery consistency. Take a medium or firm toothbrush and swish it around in the mix until fully loaded. Aim the bristles toward the canvas, then take your forefinger and drag it across the bristles. The splatters will be larger at first and get smaller as the bristles run out of paint. Keep in constant motion around the area you want splattered. Repeat this step using multiple colors and values until you have a variety of splatters.

Tip Test the splatter effect on a scrap of canvas first so you can adjust the color and size of the splatters according to your preference. The thinner the mixture, the bigger the splatters will be. I strongly recommend practicing this technique frequently until you become proficient with the process.

12 Highlight the Grasses and Brush

Mix Cadmium Yellow Light with touches of Hooker's Green and white. Then, add just a little bit of Cadmium Orange to warm it up. Thin this to a creamy consistency and load a small amount across the tip of a no. 4 bristle flat. Use an upward dry-brush stroke to begin highlighting the grass areas around the rocks and along the edge of the wash bed. This will seat the rocks and set the stage for the strong sunlight.

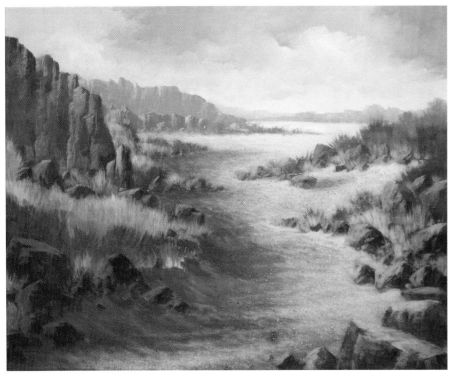

13 Build Up the Rock Formation Highlights

Mix white with a touch of Cadmium Red Light. This creates a soft pink tone when you apply it over the underpainting of the rock formations. Thin the mixture to a creamy consistency. Load a very small amount across the tip of a no. 4 Dynasty. Carefully, with a light dry-brush stroke, paint accent highlights on the rock formations. Be careful not to over-highlight, and, especially, do not highlight the distant mountains in the background.

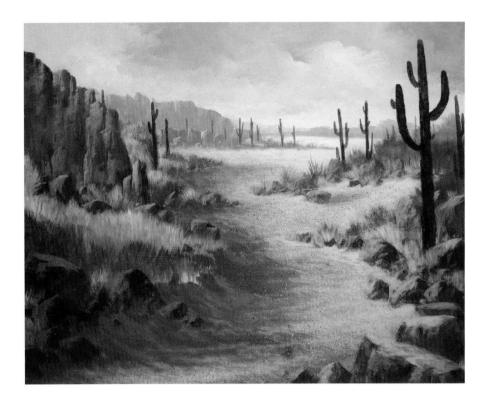

14 Underpaint the Cacti

Underpaint the cacti using a mix of Hooker's Green with a touch of Dioxazine Purple. This will be on the dark side, so to change the value, add a bit of white for the distant cacti and use less white for the foreground cacti. Position a no. 4 or no. 6 Dynasty vertically to the canvas, then form the cacti by painting across from left to right, then right to left for the other side until the strokes meet in the middle.

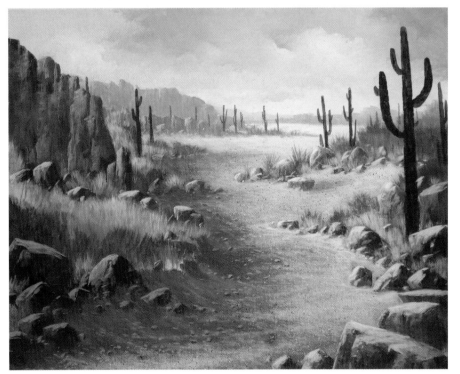

15 Continue Highlighting the Rocks

Now highlight all the rocks with a no. 4 Dynasty. Mix white with a touch of Cadmium Yellow Light. (You can also add a little Cadmium Orange or Cadmium Red Light if you wish.) Use a light dry-brush stroke to highlight all the rocks except for the ones in the far left corner. Then, mix white with touches of Dioxazine Purple and Ultramarine Blue. Thin it to almost a glaze and then apply a very thin layer to the rocks in the far left corner to create soft, cool highlights in that area.

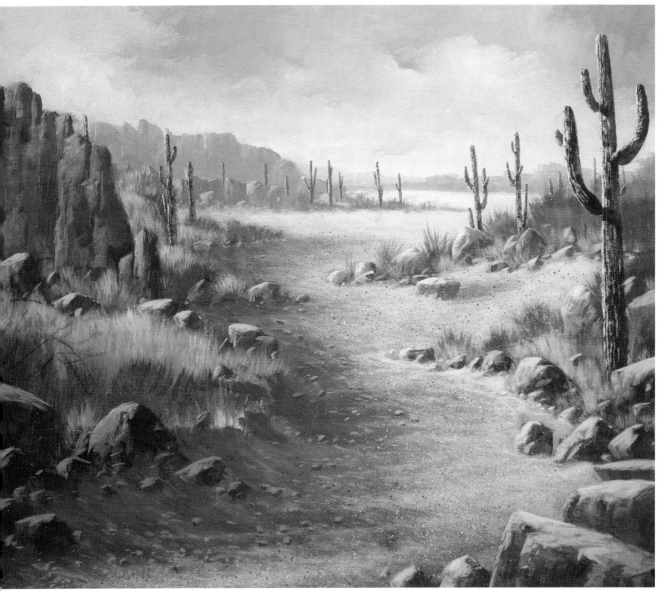

16 Highlight the Cacti

Mix white with touches of Hooker's Green and Vivid Lime Green. Load a small amount onto the chisel edge of a no. 4 Dynasty. Position the brush vertically to the cactus and begin gently tapping very thin highlights up and down the entire length of the cacti trunks and limbs. Gradually move across each cactus until about the halfway point. Leave small spaces between each row to suggest spiny ridges. Make sure the ridges are very thin, and keep the lines segmented so they do not look like hard straight lines.

17 Paint the Plants

Create a dark green mixture from 1 part Hooker's Green and ¼ part Dioxazine Purple. Use the chisel edge of a no. 2 Dynasty to paint in the thin blades of a yucca plant in front of the large rock formation. For highlights, just add a little white and a touch of Vivid Lime Green to the mixture.

For the brown base of the yucca, mix 1 part Burnt Umber and ½ part Burnt Sienna. Block it in like you did for the top, only have the blades hang down. Add a little white to the mix for highlighting.

Because the desert has such an array of vegetation, I suggest doing your own research and using your artistic license to paint the types of plants and cacti you prefer. Just move around the composition and experiment with different brushes, colors and textures. The sky is the limit, so have fun!

18 Paint the Flowers

Here again, variety, color, shapes and textures are very important. Mix up about five or six of your favorite brighter colors. Make the consistency very creamy. Then, use a dabbing technique and nos. 2, 4 and 6 bristle flats at different angles and pressures to paint flowers along the edges of the wash beds. Each brush will create a slightly different effect.

Switch to a no. 4 sable flat or round to continue painting in more flowers of different sizes, shapes and colors. Be careful not to make the foreground too busy so that it does not compete with the other main objects.

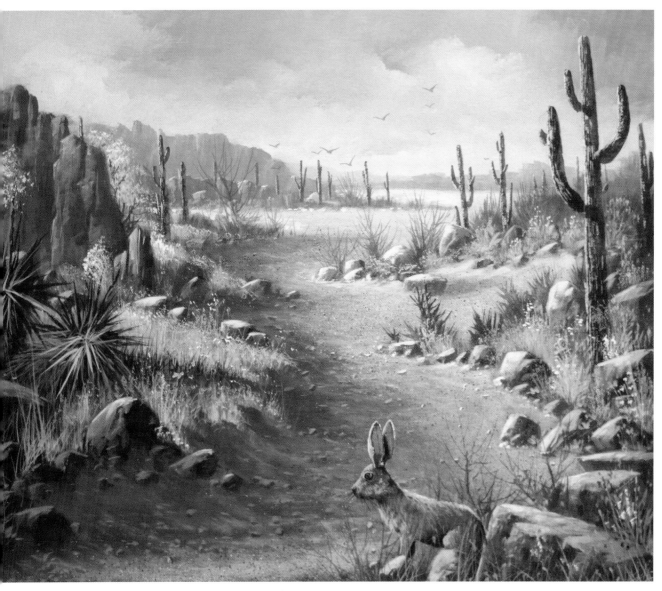

19 Paint the Jack Rabbit and Add Final Details

Jack rabbits are very large, so do not be afraid to make this guy fairly big. You might worry he appears too big, but being this close to the foreground, he really needs to be in proportion. Once you have decided where you want to place your rabbit and have worked out the proportions, underpaint him with a medium dark gray tone using a no. 4 sable flat. Then, darken the mixture and underpaint his darker shadowed areas.

Mix white with a touch of Cadmium Orange to create a soft, warm highlight tone. Slightly gray it with a little bit of Ultramarine Blue and make it a creamy consistency. Fan out a no. 4 sable round and load a small amount on the end of the brush. Drybrush short hair-like strokes beginning at the base and rear of the rabbit.

Gradually work your way up so each layer of brushstrokes overlaps the previous layer. As you go along, study your reference material and change values and colors as needed. You may need to repeat this step a few times to achieve the colors and highlights that you desire.

Mix a reddish tone from Burnt Sienna and slight touches of Cadmium Red Light and white. Paint the rabbit's eye and the ear with a no. 4 sable flat or round. Then, paint final highlights throughout the rest of the painting. You may also want to brighten up the rocks and the right side of the painting, and add additional flowers, weeds, pebbles or splatter effects as you please.

Paint a Night Scene

COMPANIONS OF THE NIGHT

For many artists, nighttime scenes with their extreme contrast of the brightly lit moon against a midnight black sky are simply too hard to resist. This is certainly true for me. And birds of prey, with their majestic forms, colors and movements, make great studies for artists who want to practice applying multiple techniques to achieve special effects.

There is a great horned owl who lives in the trees next to my studio. His silhouette against the bright glow of the moon, along with the tree stump and hanging moss, provides some interesting artistic challenges and multiple learning opportunities.

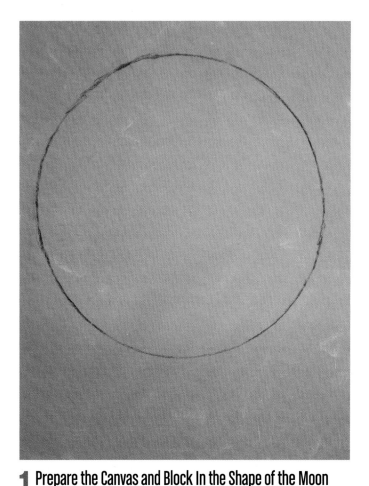

1 Prepare the Canvas and Block In the Shape of the Moon

Apply a mauvish-gray tint to the canvas with a hake brush. Let it dry. This time, instead of making a complete rough sketch of all the elements of the painting, sketch only the shape, size and location of the moon with soft vine charcoal. (You will do a more complete sketch after you paint the moon and sky.) You may need to use a circle template or compass to get the perfect round shape for the moon.

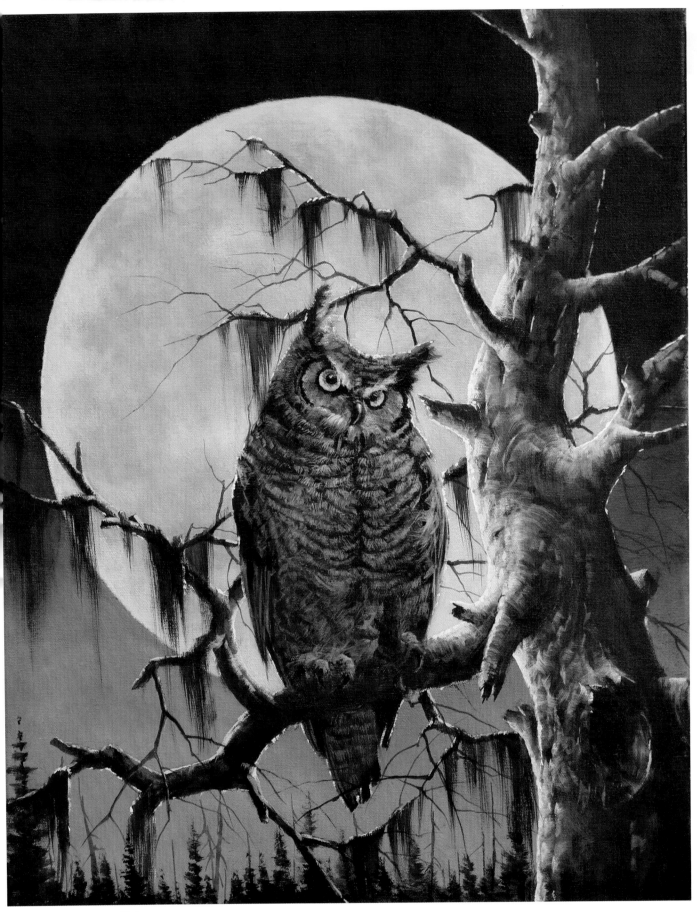

Companions of the Night
Acrylic on canvas
20" × 16" (51cm × 41cm)

2 Paint the Sky

The important thing when painting in the sky is that you create a subtle, gradated blend from top to bottom. You want the sky to be very dark at the top and end up with a medium-light value at the base. This will allow the light moon tones to contrast against the dark areas, and the pine trees to contrast against the light areas.

Mix 1 part Ultramarine Blue, 1 part Turquoise Deep and 1 part Burnt Umber with ½ part Dioxazine Purple. This will create a midnight black color. Make it a creamy consistency and load up a hake brush. Beginning at the top, start blending downward using large crisscross strokes. Work around the moon with a feather edge. Do not leave a hard line. As you come down, begin adding small amounts of white to gradually change the value. Just be sure that your value change is gradual and soft.

3 Underpaint the Moon

You will be using a mottling technique to underpaint the moon, so there is no need to pre-mix a color for this step. Apply gesso across the surface of the moon by scrubbing it on with the side of a no. 10 bristle flat. While the gesso is still wet, begin adding touches of Burnt Umber, Cadmium Yellow Light and Dioxazine Purple. Scumble these colors together using a series of overlapping, unorganized strokes. Create light and dark areas and interesting pockets of negative space to suggest the craters of the moon. Be careful not to create a hard outlined edge—it should be slightly rough.

4 Sketch the Owl and the Trees

Use soft vine charcoal and make a somewhat detailed sketch of the gnarled tree stump, the owl and the pine trees. Do not worry about extreme detail; get just enough so you can see the most important forms, proportions and pockets of negative space through the tree limbs. Also, this is the time to make sure the limb where the owl will sit is positioned exactly where you want it.

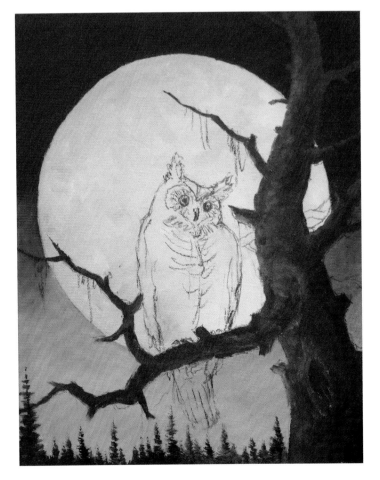

5 Paint the Trees

Mix a very dark forest green tone from equal parts Hooker's Green and Dioxazine Purple. Block in the basic form of the trees with a no. 4 bristle flat. Then, finish out the edges of each tree using either a no. 4 or no. 6 Dynasty. These trees will be very dark and contrast nicely against the sky and moon, so be sure you have a variety of shapes, sizes and interesting pockets of negative space.

Underpaint the main body of the foreground tree with a no. 6 bristle flat. Switch to a no. 2 bristle flat or a no. 4 sable flat to block in the limbs and branches. You will use multiple dark values for this, so first create a mixture of equal parts Burnt Umber and Ultramarine Blue for your base color. Paint in the dark values with loose, choppy strokes. As you go along, add small amounts of white to make slight value changes, and small amounts of Dioxazine Purple and Cadmium Red Light with more Ultramarine Blue to create subtle tonal changes. Apply the paint thickly and leave visible brushstrokes to create a slight texture.

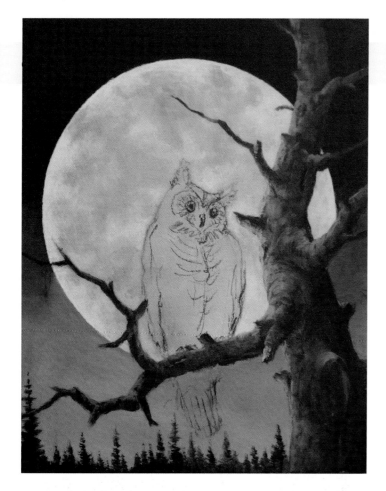

6 Highlight the Foreground Tree and the Moon

Now will begin the first phase for creating a twisted, gnarled effect on the foreground tree. The key here is not to over-highlight and to make sure you leave various pockets of negative space to suggest recessed areas of the wood. This is only the form highlight, so the main purpose is to design the character of the tree and show the proper attachment of the limbs to the trunk. Create a mixture of white with touches of Ultramarine Blue and Cadmium Orange. Make it a glaze-like consistency. Load a small amount onto the tip of a no. 2 or 4 Dynasty and create the suggestion of weathered bark with brushstrokes of various angles and pressures .

Next, highlight the moon to brighten and give it a stronger glow. Mix white with touches of Burnt Umber and Cadmium Yellow Light. Make it a creamy consistency. Load a small amount on a no. 6 bristle flat and begin scumbling and scrubbing the color across the surface of the moon using various amounts of pressure to create subtle value changes. The main goal here is to exaggerate the formations of the craters by highlighting around them, leaving irregular pockets of space to suggest a slightly depressed effect. You may have to repeat this step a couple more times to get the craters to show up as much as you desire.

7 Underpaint the Owl

By now the sketch of the owl is probably somewhat distorted, so take your vine charcoal and correct the sketch, making absolutely sure it is in proportion. Now it's ready to be underpainted.

Mix Burnt Umber with a small dab of Ultramarine Blue to slightly cool down the brown tone. Add just enough white to create a medium-dark value. Paint in the darker areas of the owl with a no. 4 bristle flat. Do not leave any hard edges—make sure they are all soft. Add a slight touch of white to the mixture and underpaint the lighter areas. Remember, this is only an underpainting—you will brighten the lighter areas later as needed.

Next, mix equal parts Burnt Umber and Ultramarine Blue with a touch of Dioxazine Purple. Block in the eye-sockets, ears and other very dark areas with a no. 4 sable flat.

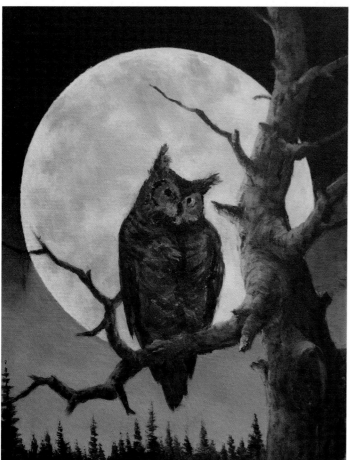

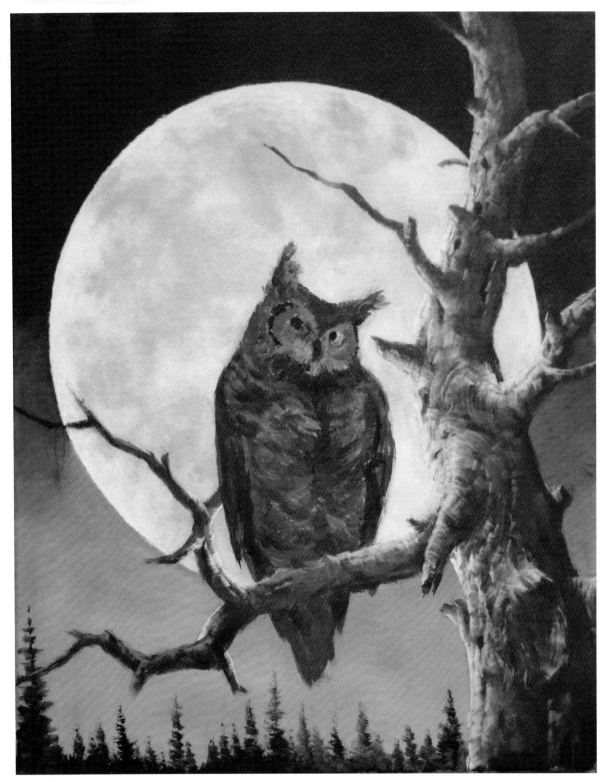

8 Continue Developing the Foreground Tree

Because the moon is the main source of light here, we end up with back lighting, which means the front of the foreground tree is somewhat in shadow. Also, keep in mind that moonlight is softer and much less concentrated than sunlight.

Mix white with touches of Cadmium Orange and Ultramarine Blue. This will create a soft but semi-bright warm highlight. Load a small amount on a no. 6 Dynasty, angle it vertically to the canvas, and make short, choppy strokes up and down the trunk. This will create the suggestion of rough bark.

Switch to a no. 4 Dynasty to underpaint the additional limbs and shorter branches. Mix white with a touch of Cadmium Orange and dab highlights along the edge of the tree limbs. Be sure to use broken, choppy strokes to create the suggestion of rugged bark. You can also add some foreshortened tree limbs, if you wish.

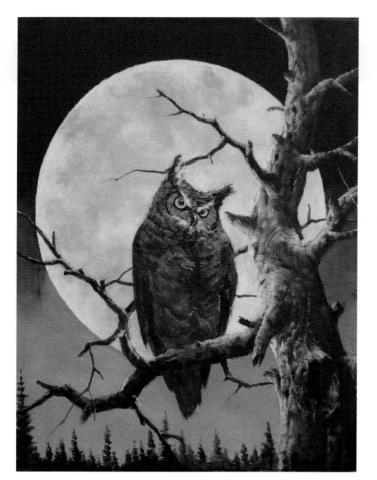

9 Paint the Owl's Eye and Beak

It is a fairly common practice when painting wildlife to paint the eyes first because this gives you a good place to start building. The eyesockets should already be dark from the underpainting. Now, create a small color mixture from 1 part Cadmium Yellow Light and 1 part Cadmium Orange. With a no. 4 sable round, carefully paint a gold ring around the pupil. Continue to work with this until the pupil is perfectly round.

Mix equal parts Ultramarine Blue and Burnt Umber. Use the same brush to paint a narrow ring around the eye. Work it until you get the shape you want. You will have to make this outer ring slightly wider than you might think it should be because, as you add the feathers around this area, it will shrink some.

Use a no. 4 sable round to paint the beak a medium-dark charcoal gray color. Lighten it slightly on the top.

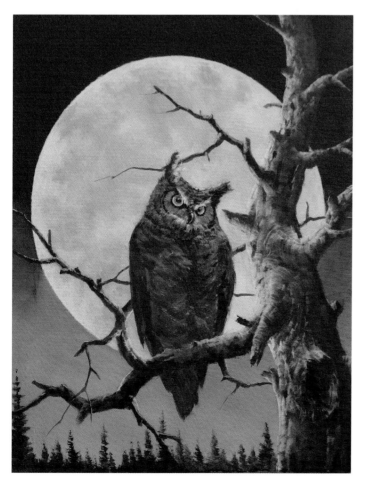

10 Develop the Owl's Face and Head

Start with a base mixture of 1 part Burnt Sienna and ¼ part Burnt Umber. Add just enough white to create a soft warm brown, then add a small touch of Cadmium Orange to create a butterscotch color. With a no. 2 Dynasty, drybrush the mask of the owl's face around the eyes to help seat them in the sockets. Then using the same brush and color mixture, add different amounts of white to create a variety of values and tones, and begin dabbing in various patches to suggest feathers on top of the head, ears and neck. Add more white for the area above the eyes and eyebrows and around and below the beak, plus a few tufts of feathers on the ears.

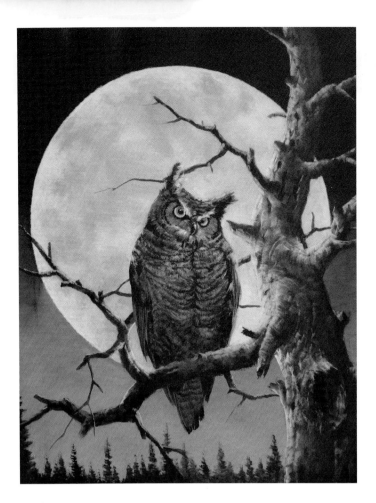

11 Develop the Owl's Body

Mix white with touches of Burnt Umber and Cadmium Yellow Light. Make it very creamy. This color can vary depending on how much of each color is added, so experiment with different values and tones. Load a no. 2 Dynasty with small amounts of the color mixture and drybrush in a feather pattern across the front of the body. Keep in mind there are two separate sides of the body, so be sure to follow the contour of the body on each side. This will help to make him look more dimensional. You may have to go back in with some of the very dark formula you used in step 7 to create more contrasting areas.

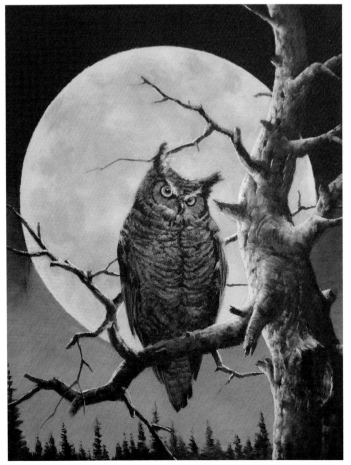

12 Finish Highlighting the Moon and Tree

This is a very short and simple step. All you need to do here is paint the final bright highlights on the moon and tree trunk. For the trunk, mix 1 part white with ¼ part Cadmium Orange. Load a no. 4 or no. 6 Dynasty and dab the color along the trunk and larger limbs of the foreground tree.

For the moon, create a mixture from equal parts Cadmium Yellow Light and white, then add a touch of Burnt Umber. Load a no. 6 bristle flat and scrub and scumble the color into various areas of the moon to give it its final glow.

Tip

Remember that you may have to add three or four layers of highlights to achieve the brightness you want. Several thin layers of highlight will help you achieve your desired effect better than a couple of thick layers will.

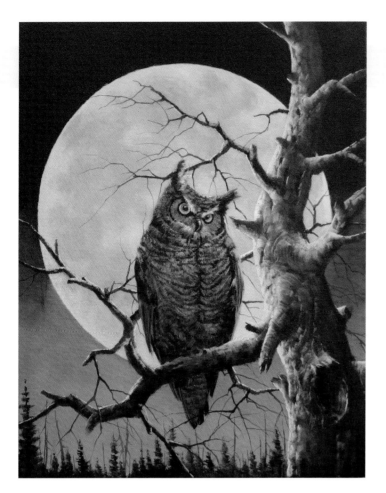

13 Finish the Tree Limbs

Finish the composition of all of the overlapping limbs to prepare the tree with good spots for the moss to hang on. Mix equal parts Burnt Umber and Ultramarine Blue. Thin it to an ink-like consistency. Load a no. 4 sable script and finish painting the tree limbs. You can also add some additional limbs to create interesting negative space. Just be careful not to overdo it at this point—you can always add more limbs later if needed.

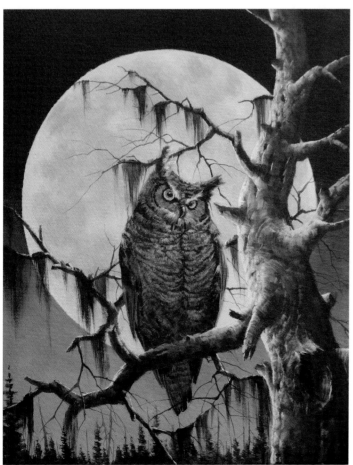

14 Paint the Hanging Moss

Mix 1 part Hooker's Green and 1 part Dioxazine Purple. Make the mixture very creamy. Use a no. 6 Dynasty to paint in the hanging moss. Position the brush horizontally to the canvas and drag it straight down using a choppy dry-brush stroke. The most important thing is to make sure that the moss is scattered throughout the limb structures with different lengths, shapes and sizes. As always, remember to include interesting pockets of negative space to create good eye flow.

15 Add a Silver Lining

A silver lining is a very thin, bright highlight on the edge of an object. It is caused by backlight coming from directly behind an object. Mix equal parts Cadmium Yellow Light and Cadmium Orange, then add a touch of white. With a no. 4 sable round, carefully paint broken, segmented lines along the edges of the owl and the foreground tree.

16 Add Final Details

At first glance, you may not see much of a change with this final step, but if you look closely, a few miscellaneous details and highlights will pop out. Paint the tiniest tree limbs with a no. 4 sable script and 50/50 mixture of Ultramarine Blue and Burnt Sienna thinned to an ink-like consistency.

Mix equal parts Burnt Umber with Ultramarine Blue with enough white to create a soft, warm gray tone. Paint the owl's talons wrapped around the tree limb with a no. 4 sable round. Drybrush in some soft feathers around the talons.

Brighten the eyes and add more highlights on the feathers as needed.

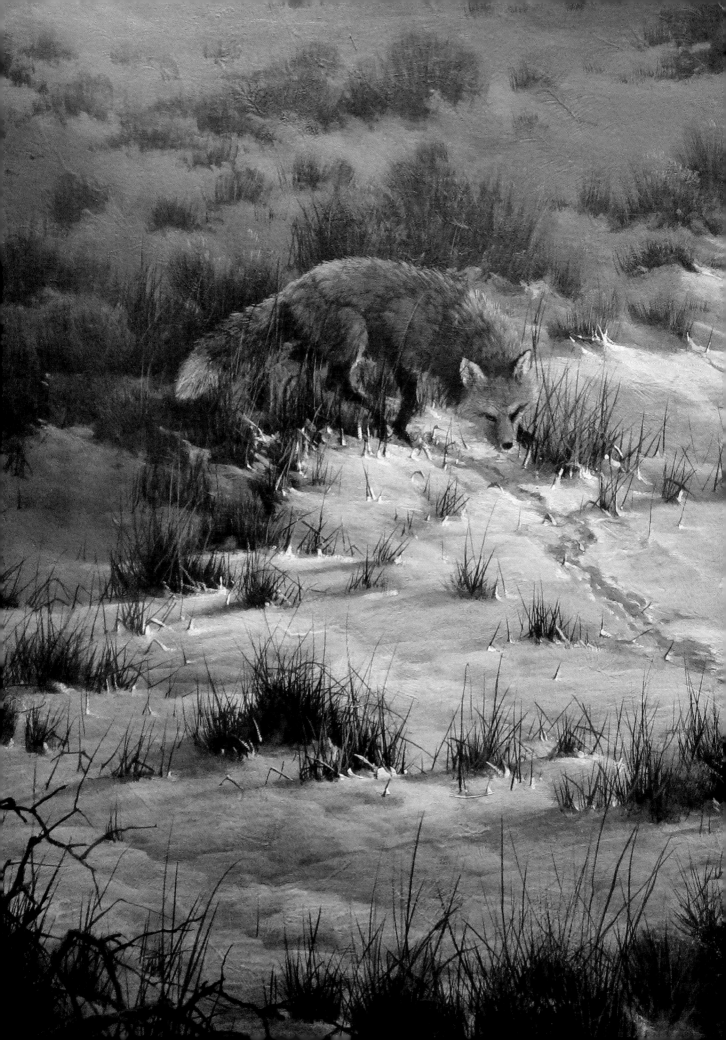

Seasons

Everyone has a favorite season. Some folks even choose to live in certain areas of the country in order to experience the atmosphere and climate of certain seasons for longer periods of time. Personally, I love all four seasons, so I chose to live in a region where I can enjoy each one in its full glory of color and atmosphere.

The four seasons are a great tool for artists to practice various brush techniques, color schemes, compositions, atmospheres and so on. Whether it be a cold, snowy winter evening, a hot blistering summer afternoon, a bright cheerful spring morning or a colorful array of rich autumn hues, painting the four seasons will challenge every phase of your artistic ability and help you acquire the necessary disciplined skills of color mixing, color harmony and values.

Tracking
Acrylic on canvas
24" × 36" (61cm × 91cm)

Paint a Spring Scene

SPRINGTIME MIRACLE

Living in the Midwest is a unique experience. Contrary to what many people believe, we do not live in a dust bowl. We are actually surrounded by some of the most beautiful scenery in the country. We may not have majestic, rugged mountains or giant waterfalls, but in many ways, we have something even more spectacular.

Springtime in the Midwest is truly amazing to behold. The beautiful green pastures, rolling hills and open grasslands are home to an endless array of wildlife. As you gaze across the horizon, you will see massive herds of free-roaming buffalo grazing on spring grasses or beautiful horses standing like statues in fields of wild flowers. And then, suddenly, you see them—little baby colts nestled in the shadows of their mothers' giant bodies!

Materials

SURFACE
16" × 20" (41cm × 51cm) stretched canvas

ACRYLIC PIGMENTS
Burnt Sienna, Burnt Umber, Cadmium Orange, Cadmium Yellow Light, Dioxazine Purple, Hooker's Green, Ultramarine Blue, Vivid Lime Green

BRUSHES
- 2" (51mm) hake
- nos. 2, 4, 6, 10 and 12 bristle flats
- nos. 2 and 4 Dynasty
- no. 4 sable round
- no. 4 sable script

OTHER
- soft vine charcoal
- white gesso

1 Prepare the Canvas and Sketch the Composition
Use a no. 12 bristle flat to apply a greenish-gray tint to the canvas. Once dry, loosely sketch the main landmasses and subjects of the composition with soft vine charcoal.

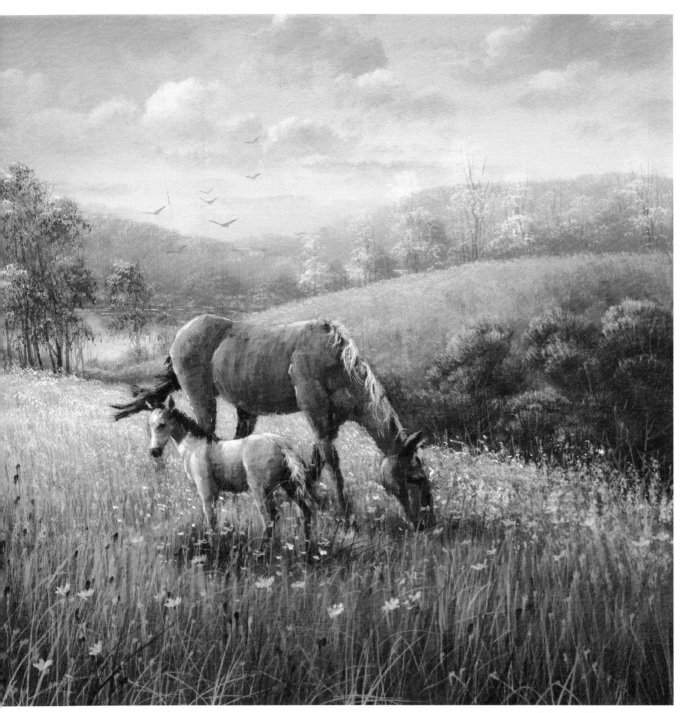

Springtime Miracle
Acrylic on canvas
16" × 20" (41cm × 51cm)

2 Underpaint the Sky

Apply an even coat of gesso to the sky area with a hake brush. Be sure it is well covered. While the gesso is still wet, take a small amount of Cadmium Yellow Light and a touch of Cadmium Orange and blend this across the horizon and about halfway up the sky. Quickly clean off the brush and then apply a small amount of Ultramarine Blue and a touch of Dioxazine Purple across the top of the sky. Using long, crisscross feather-light strokes, carefully blend downward into the horizon color until you have a softly blended sky without any hard edges. Be careful not to over-blend, or it will turn to mud. Do not be afraid to adjust the color to fit your own desire.

3 Paint the Distant Hills

Create a cool mauvish-gray by mixing white with a touch of Ultramarine Blue, Dioxazine Purple and Burnt Sienna. This should end up being about two values darker than the horizon. Scrub the color into the first layer of distant hills with a no. 4 bristle flat. Make sure the edges are soft.

Darken the color mixture by about two values, then add a very small touch of Hooker's Green. Scrub in the second layer of distant hills. Again, keep the edges soft.

4 Paint the Clouds

Create a soft gray mixture that is a medium-light value. Load a small amount onto the chisel edge of a no. 4 bristle flat and gradually begin scrubbing in a soft collection of gray clouds. Be sure you are creating good negative space—don't line them all up in a row.

Mix white with a touch of Cadmium Orange. Load a very small amount onto the chisel edge of a no. 2 bristle flat and carefully scrub soft cap highlights on top of some of the larger clouds to give them a more three-dimensional form. Do not make them too bright; you can always brighten them up later.

5 Continue Developing the Distant Hills

Create a soft, grayish-green color by mixing 1 part Hooker's Green, ¼ part Dioxazine Purple and just enough white to create a value about two values darker than you used to paint the hills in step 3. (You may have to add a touch of Ultramarine Blue and Burnt Sienna to achieve the value and the color you want.) Use a no. 4 bristle flat to begin scrubbing this color into the third layer of distant hills. Since these hills are tree-covered, they should have a bit more form to them. Use vertical strokes at the very top of the hill to suggest subtle tree shapes.

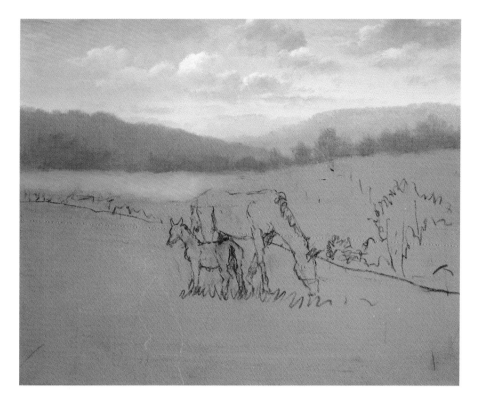

6 Paint More Distant Trees and Underpaint the Water

To add more distant trees on the right side of the composition, create a color mixture from 1 part Hooker's Green, ¼ part Dioxazine Purple and enough white to make a color about two values darker than you used for the hills in the previous step. Use a no. 4 bristle flat to dab in the tree shapes with a little individual character.

Use the same brush to underpaint the water with a mixture of white plus a touch of Ultramarine Blue and a slight amount of Dioxazine Purple. You will add reflections, highlights and other details later.

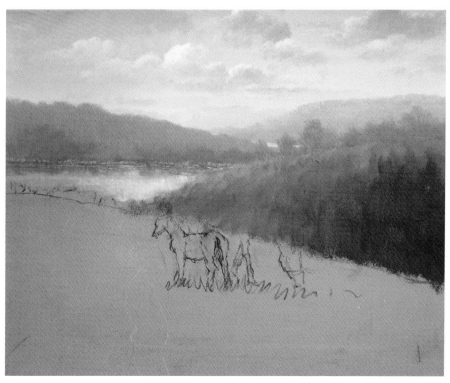

7 Underpaint the Grassy Hillside

Now it's time to underpaint the large grassy hillside on the right side of the composition. Remember, you are only underpainting at this stage, so all you need to do is get a good value change from light at the top to a darker value at the base. Create a medium green mixture from equal parts Hooker's Green and Cadmium Yellow Light. Take a no. 10 bristle flat and scrub a thin layer of Cadmium Yellow Light across the top of the hill. Then, turn the brush sideways and, using the mixture you just created, begin scrubbing with vertical strokes to blend into the Cadmium Yellow Light. As you come down the hill, add small amounts of Dioxazine Purple and small touches of Cadmium Orange until you have three basic values from light to dark.

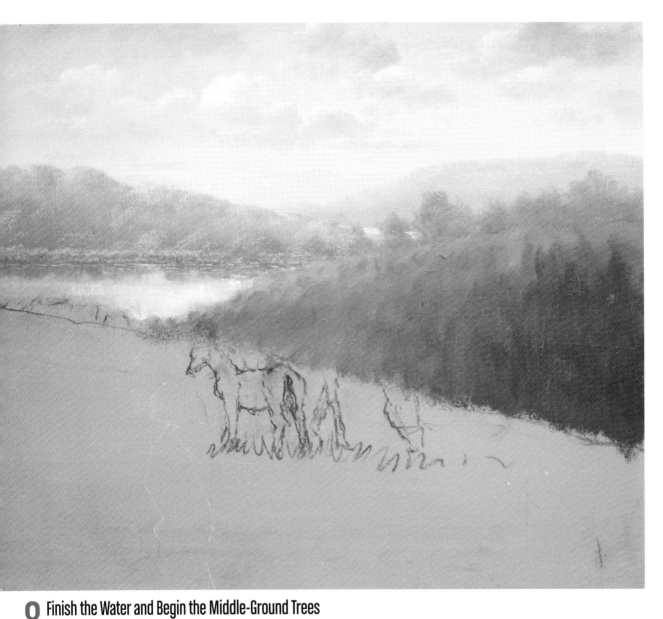

8 Finish the Water and Begin the Middle-Ground Trees

Create a grayish-green mixture from equal parts Dioxazine Purple and Hooker's Green. Add enough white to create a medium value. With a no. 2 bristle flat, drybrush short, vertical strokes from the shoreline downward to suggest the reflection of the hill. Mix a warm highlight color of white plus a touch of Burnt Umber. Use a no. 4 sable round to dab a few highlights along the shoreline and suggest dirt and small rocks. Do not make them too bright.

Mix a little white with a touch of Ultramarine Blue and use a no. 2 bristle flat to paint a dry-brush glaze across the water. It should be two or three values lighter than the underpainting.

In keeping with the springtime theme, begin highlighting the hill with lighter green and yellow-green tones. Mix Cadmium Yellow Light with touches of Hooker's Green and Cadmium Orange and just enough white to make it slightly opaque. Load the tip of a no. 4 bristle flat and dab the highlights along the ridge and down the front of the hill. Create pockets that suggest the shape of trees, brush and grasses.

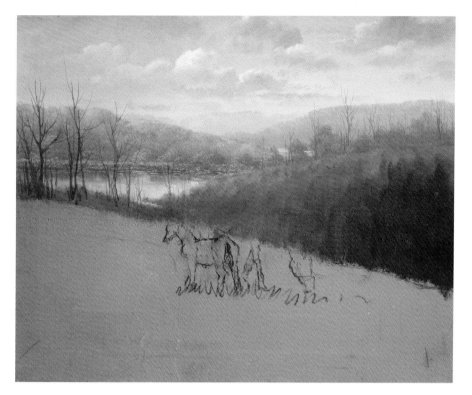

9 Paint the Tree Trunks

Mix a mauvish-gray tone that is about a medium value. Start with Ultramarine Blue with a touch of Burnt Sienna, plus white and Dioxazine Purple. Thin it to an ink-like consistency. Paint the tree trunks in front of the water and along the top of the right hillside with a no. 4 sable script.

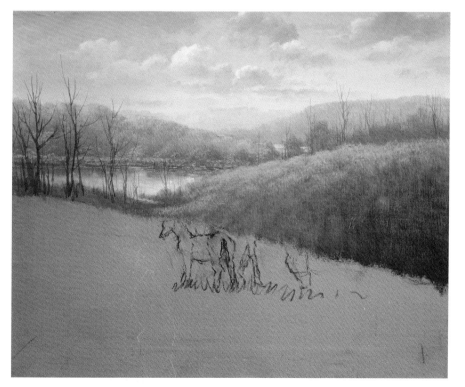

10 Highlight the Hillside

Highlight the hillside using the spring-green color mixture of equal parts Hooker's Green and Cadmium Yellow Light that you used in step 7. (Of course, you may adjust it as you like. Feel free to add more or less yellow or a touch of Cadmium Orange.) Drybrush short, vertical strokes across the top and down the face of the hill with a no. 6 bristle flat. Repeat this step once or twice to get a nice transition.

11 Underpaint the Foreground Meadow

Load a no. 10 bristle flat with Hooker's Green. Apply it fairly thick to the foreground meadow area to get good coverage and a little texture. Begin scrubbing with short, vertical strokes. As you go across, add touches of Cadmium Yellow Light and Cadmium Orange to create lighter, softer areas. As you come down, add small amounts of Dioxazine Purple and Burnt Sienna. The overall finish should be a medium dark tone.

12 Paint the Leaves and Bushes

Create a medium olive-green color from 1 part Hooker's Green, ¼ part Burnt Sienna and a slight touch of Dioxazine Purple. (In this particular case, if you need to adjust the value, just add a little Cadmium Yellow Light.) Use a no. 4 or no. 2 bristle flat to dab on the leaf pattern of the tree trunks in front of the water on the left. Be sure not to overdo it. Keep in mind this is late spring, and the leaves need to be lacy and airy, so tap lightly.

Darken the mixture with more Hooker's Green and Dioxazine Purple, then paint in the large bushes on the lower right. Clean the brush and, with Vivid Lime Green and a touch of Cadmium Yellow Light, gently tap on the leaf pattern of the very distant trees.

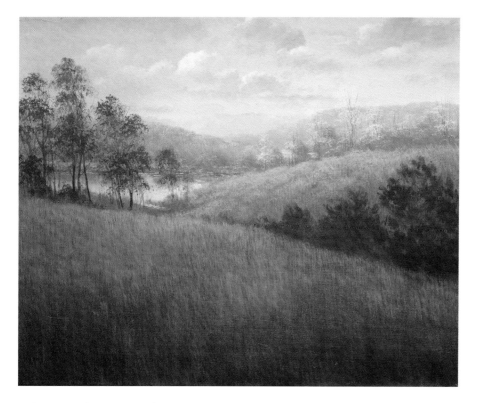

13 Begin Highlighting the Foreground Meadow

Mix 1 part Cadmium Yellow Light and ¼ part Hooker's Green to a creamy consistency. Load a small amount across the tip of a no. 10 bristle flat. (It is important you use a brush that has a good, straight chisel on the tip. If it is too worn down, it will not work very well.) With quick yet careful overlapping vertical strokes, lightly drybrush the surface of the meadow from top to bottom. When finished, you should have a soft, subtle gradation of value from light to dark.

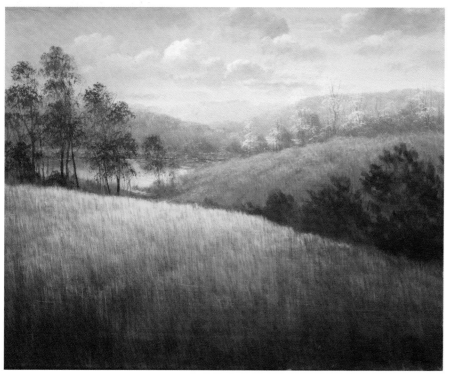

14 Continue Highlighting the Meadow

This step is identical to the previous one. You will just use brighter tones and more visible brushstrokes to begin suggesting the taller meadow grasses. Add a little more Cadmium Yellow Light and/or Vivid Lime Green to the mixture you used in the last step. Make it very creamy, then load a small amount on the tip of a no. 10 or no. 6 bristle flat. Begin at the top of the hill and drybrush in vertical strokes, gradually making them a bit longer as you move down the hill. Repeat this process until you get the brightness you want. Just make sure that you end up with three values: light, medium and dark.

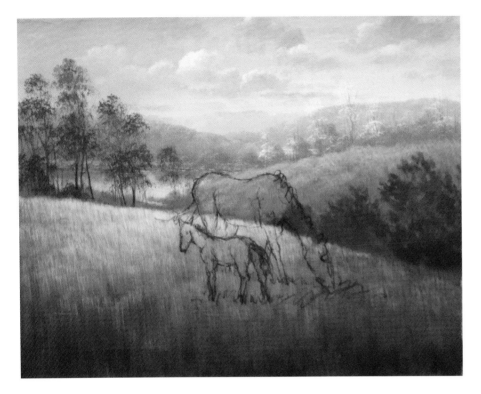

15 Re-sketch the Horses
With soft vine charcoal, make a proportionally accurate and anatomically correct sketch of the horses. You do not have to worry about making it very detailed. Details will come later with your brushwork.

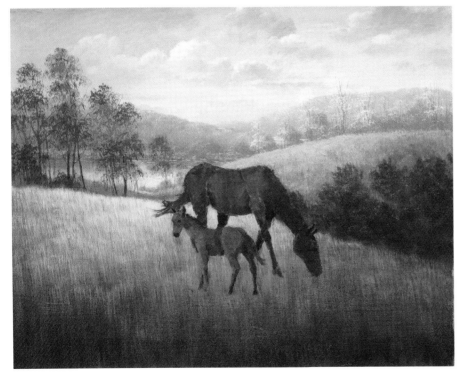

16 Underpaint the Horses
Mix a warm gray tone from 1 part Burnt Umber, ¼ part Ultramarine Blue and just enough white to create a medium-dark value. Underpaint both horses with nos. 2 and 4 Dynasty. You will need to add touches of white to create subtle value changes to show the separation of the body parts.

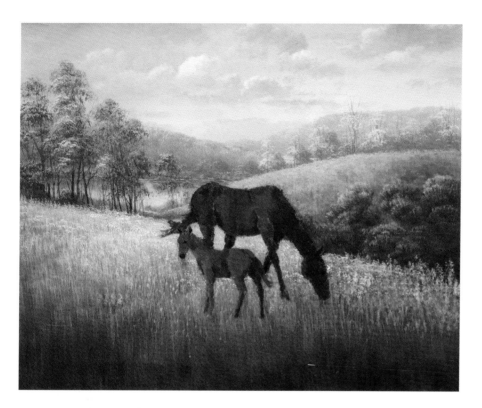

17 Highlight and Detail the Trees and Grasses

Mix 1 part Cadmium Yellow Light and ¼ part Hooker's Green. This will be a base mixture, so don't hesitate to add various other colors to create different greens if you wish. Use a no. 4 bristle flat to dab highlights on the trees and bushes. Then, use the same technique to dab some distant flowers on the hillside in any color you like. Use vertical and horizontal brushstrokes.

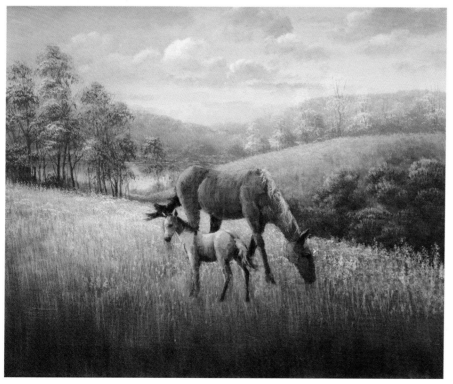

18 Highlight the Horses

Mix white with a touch of Burnt Umber and Burnt Sienna. (If you want your horses to be more of a rust color, add some Cadmium Orange to the mixture.) Thin it to almost a glaze, then paint highlights onto the mother horse with a no. 2 Dynasty. Be sure to allow some of the underpainting color to show through to create the shadows where body parts overlap. You may have to layer these highlights four or five times to achieve your desired value.

Next, follow the same process to paint the colt. If you want to make it a different color, as was done here, add a bit more white, Cadmium Orange or Ultramarine Blue to make a cooler tone.

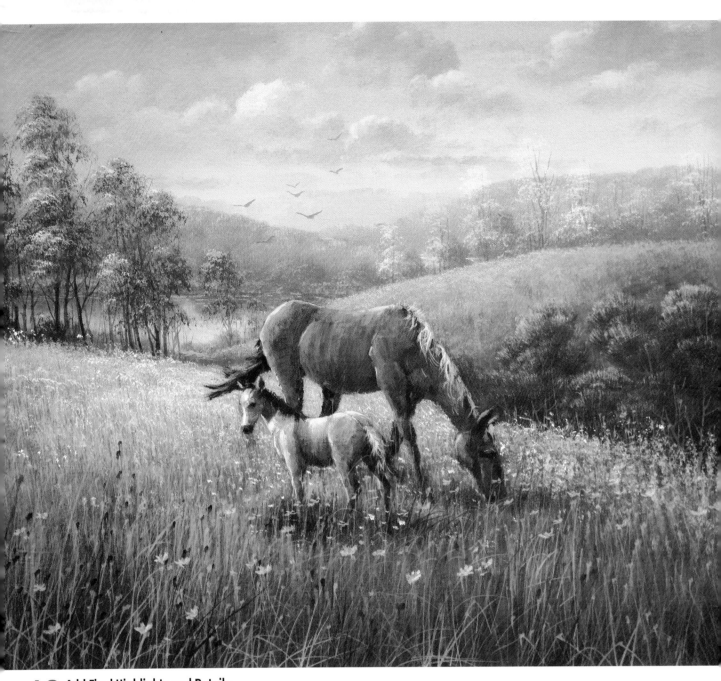

19 Add Final Highlights and Details

This is another great place to exercise your artistic license. Step back and evaluate your progress, then finish highlighting and detailing the trees, grasses and horses.

Mix Cadmium Yellow Light with a bit of Hooker's Green, and thin it to an ink-like consistency. Paint flowers and tall, light weeds through the foreground with a no. 4 sable script.

Switch to a no. 4 bristle flat and add a small amount of Hooker's Green with a touch of Dioxazine Purple to create the cast shadow beneath the horses. Use short, vertical dry-brush strokes, and be sure not to leave any hard edges. Finally, bring up the highlights on the main subjects to create more sunlight.

Tip The best average viewing distance from a painting is about 6 feet (1.8m) away. Stand back and evaluate your work often.

Paint a Summer Scene

TROPICAL PARADISE

I have never been to any tropical place, let alone a tropical paradise. However, the beautiful thing about being an artist is that you can wake up on any given day and be anywhere you want to be. In this painting demonstration we will visit a summertime tropical paradise that will allow you to really test your artistic abilities and exercise your creative license.

This beautiful late evening sunset has multiple color combinations and a balance of warm and cool colors that all work together. A wide variety of techniques are used to create different effects, such as the sun rays, the sandy beach, the sharp edges of the palm fronds and the pelican and seagulls. These elements, along with a solid composition, make this a successful and fun painting.

1 Prepare the Canvas and Sketch the Composition

Use a no. 12 bristle flat to apply a warm gray tint to the canvas. Once dry, sketch the main compositional elements including the horizon line, ground contours, pier post, pelican and seagulls with soft vine charcoal. Keep in mind that this doesn't need to be very detailed because you will be painting over it.

Materials

SURFACE
16" × 20" (41cm × 51cm) stretched canvas

ACRYLIC PIGMENTS
Burnt Sienna, Burnt Umber, Cadmium Orange, Cadmium Yellow Light, Dioxazine Purple, Hooker's Green, Turquoise Deep, Ultramarine Blue

BRUSHES
- 2" (51mm) hake
- nos. 4, 6, 10 and 12 bristle flats
- nos. 2 and 4 Dynasty
- no. 4 sable round
- no. 4 sable script

OTHER
- medium or firm toothbrush
- paper towel
- soft vine charcoal
- white gesso

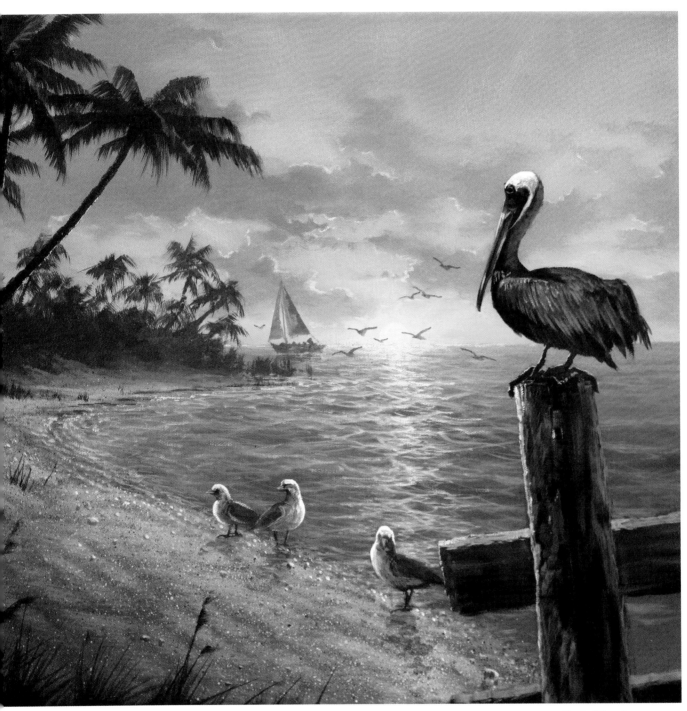

Tropical Paradise
Acrylic on canvas
16" × 20" (41cm × 51cm)

2 Underpaint the Sky

Apply gesso liberally with a hake brush, using large overlapping crisscross strokes. While the gesso is still wet, add Cadmium Orange at the base of the sky and blend upwards until it fades in (about half-way up). Rinse the brush, then take Ultramarine Blue and a bit of Turquoise Deep and streak it across the top. Blend downward using large crisscross strokes. As you get into the orange-tinted area, use feather-light strokes to blend the two colors together. Do not over-blend, or it will become muddy. You will brighten these colors in the next steps.

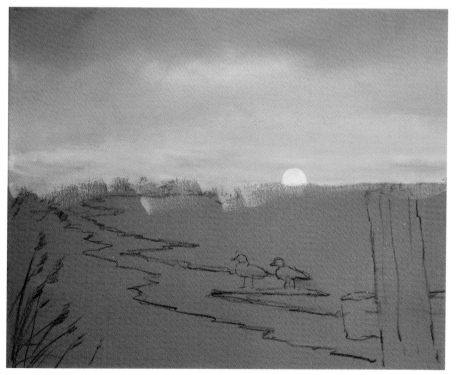

3 Brighten the Sky and Add the Sun

Double-load a no. 10 bristle flat with Cadmium Yellow Light and Cadmium Orange. Using long horizontal strokes, scrub along the horizon, gradually lightening your strokes as you work your way up. The yellow-orange color should fade into the upper area of the sky.

Load a no. 4 bristle flat with Cadmium Yellow Light and a little white, then paint in a sun that is about ¾ of the way above the horizon.

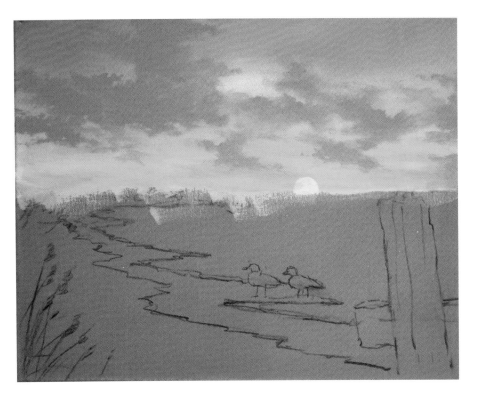

4 Underpaint the Clouds

Create a mixture of 1 part Ultramarine Blue, ¼ part Burnt Sienna, a touch of Dioxazine Purple and just enough white to create a mauvish-gray middle-value tone. Begin scrubbing in very soft cloud formations with a no. 4 or no. 6 bristle flat. It is important to keep the edges of the clouds very soft. Also, be sure to arrange the clouds so they create interesting pockets of negative space for a pleasing eye flow.

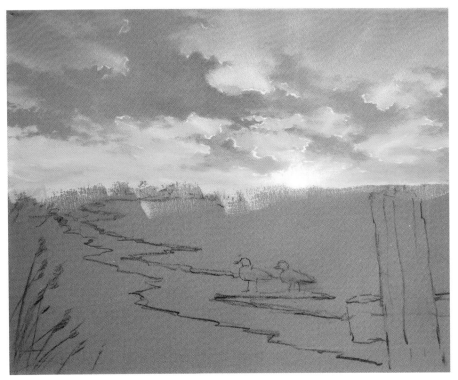

5 Highlight the Clouds and Sun

Load a no. 4 sable round with a mixture of Cadmium Yellow Light and white and dab it on the edge of most of the cloud formations. It is not necessary to highlight every single cloud. Just use good artistic common sense and be sure to use broken, segmented lines instead of solid outlines.

Load a no. 6 bristle flat with a mixture of 1 part Cadmium Yellow Light and ¼ part white. Drybrush in a bright glow around the sun as well as sun rays streaming through the clouds.

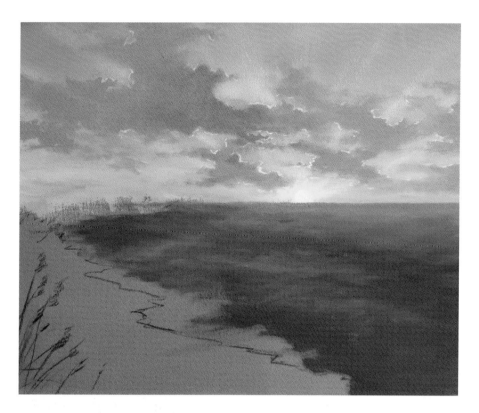

6 Underpaint the Water

The first phase of underpainting the water is to put the darker undertones in place. Use a no. 6 bristle flat to apply darker versions of the mauvish-gray and blue sky tones you mixed earlier. You'll want to darken each of them by about two values. Start at the horizon and begin applying the blue tones using long vertical strokes. Gradually add the darker mauvish-gray mixture as you come down toward the bottom of the canvas. This should be a medium-dark value with slight movement in the brushstrokes.

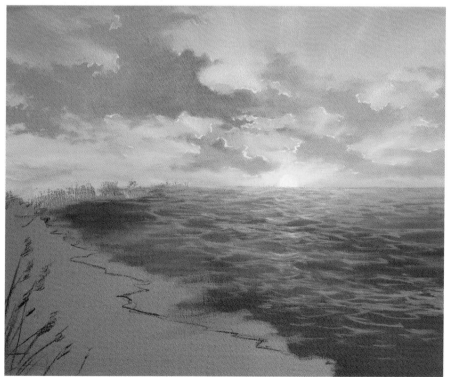

7 Begin Highlighting the Water

Take the mauvish-gray mixture that you used to underpaint the water in the previous step and add enough white to make it about two values lighter. Load a no. 4 bristle flat and position it horizontal to the canvas, then begin painting the first layer of water highlights using long, flat comma-shaped strokes (I like to call them "lazy banana" strokes). Be sure to leave interesting pockets of negative space and overlap your brushstrokes to create good eye flow.

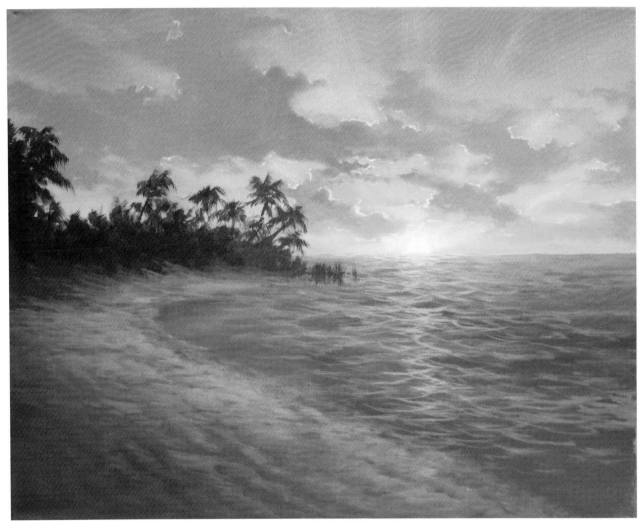

8 Continue Highlighting the Water and Underpaint the Trees and Beach

Mix Cadmium Yellow Light with a touch of Cadmium Orange and white. This should give you a soft gold tone. Thin it to a creamy consistency. Load a no. 2 Dynasty and position it horizontally to the canvas, then begin applying the next layer of brighter highlights. Keep most of the highlights toward the center of the water, gradually fading them out toward the edges and all the way down to the foreground. The key here is to be sure not to over-paint so you don't lose those pockets of underpainting. Make sure you remember to create a little movement in the water.

Next, underpaint the small segment of the island and distant palm trees that stick out on the left. Create a creamy mixture of 1 part Hooker's Green and ¼ part Dioxazine Purple. Paint in the main mass of the island with a no. 6 bristle flat. Switch to a no. 2 Dynasty and drybrush in the tops of the palm trees and other underbrush along the ridge of the island. Once again, be sure to create some interesting pockets of negative space.

To underpaint the beach, mix Burnt Umber with enough white to get a medium-warm tan tone. Use a no. 6 bristle flat to scrub in the beach area. As you go along, add touches of Dioxazine Purple and Ultramarine Blue to create slight variations in color and value. Be sure to create an irregular shore with the proper ellipses to make the shoreline appear flat. Keep in mind that in the next few steps you will add other layers of highlights and details, so do not underpaint the beach too light.

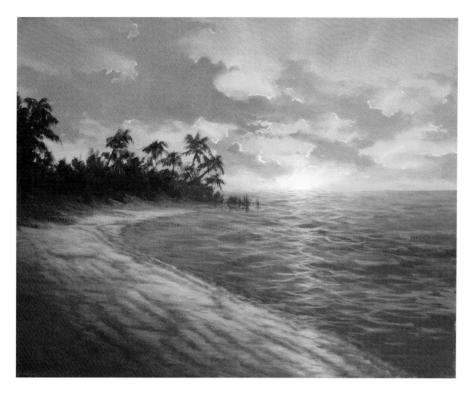

9 Begin Highlighting the Beach

Mix 1 part white, ½ part Burnt Umber and a small touch of Cadmium Yellow Light. This will create a light goldish-tan tone. Thin it to a creamy consistency, load a no. 4 or no. 6 bristle flat and begin applying the first layer of highlights to the beach area. Keep the area toward the shoreline the lightest by using linear elliptical strokes to suggest water that has washed up and receded.

Switch to a no. 4 Dynasty to apply paint when creating the effect of eroded, washed sand. Use a mixture of white with touches of Cadmium Yellow Light and Burnt Umber. Keep it very light on the golden side.

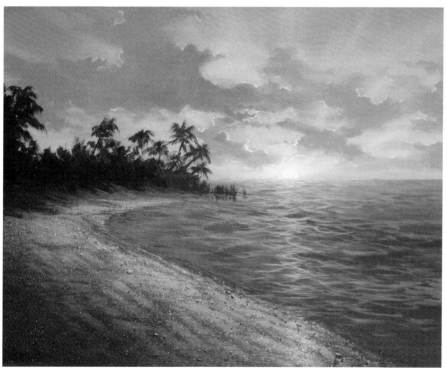

10 Create the Sand Texture

Use a medium or firm toothbrush to apply the next layer of highlights to the sand. Mix white with a touch of Burnt Umber. Thin it down to an ink-like consistency, then load the toothbrush. With the brush facing down, pull your forefinger across the bristles to begin splattering the beach. You can use a wide variety of values, colors and sizes of splatters. Just experiment until you find what you like. Wipe off any overspray with a damp paper towel. And remember to have fun!

Tip Nature is your best teacher— study it with intensity.

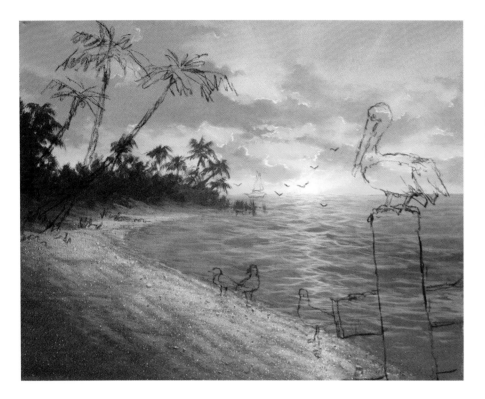

11 Re-sketch the Main Components

Use soft vine charcoal to re-sketch the main components of the composition. Pay close attention to the proportions of each object so they all work in harmony with each other to create good eye flow.

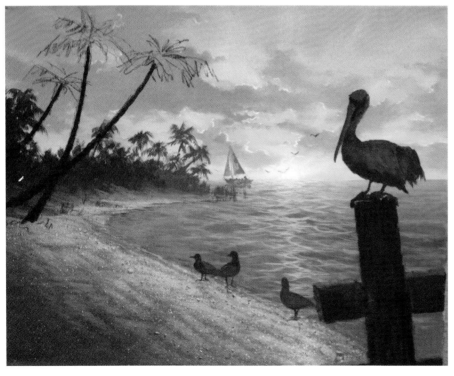

12 Underpaint the Remaining Components

Create a dark mixture from 1 part Ultramarine Blue, ¼ part Burnt Sienna and a touch of Dioxazine Purple. Use a no. 6 bristle flat to underpaint the pier post and boards with long, choppy strokes. Leave some of the brushstrokes showing. Block in the pelican using different values of medium gray tones to help make the various body parts clearer. Lighten the value slightly and underpaint the seagulls. Then, lighten it a bit more and underpaint the sailboat. Follow the basic theory that objects in the foreground are darker and become lighter as they recede.

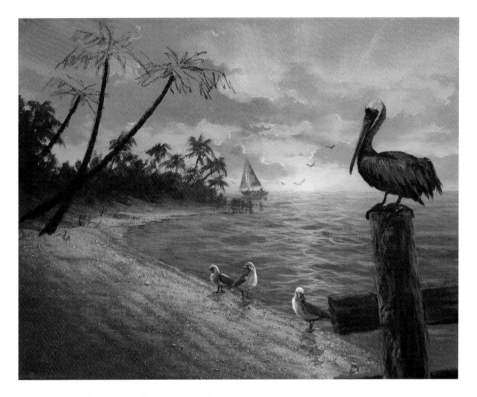

13 Highlight the Main Components

Create a creamy mixture from 1 part white, ¼ part Ultramarine Blue and ¼ part Burnt Sienna. Use a no. 4 sable round to begin applying different gray values, adding more white as needed to lighten the values. Remember to only apply enough highlight to give basic form. These objects do not require much highlighting because they are backlit. Just follow the concept of creating form by going from dark to light in a gradual gradation of values.

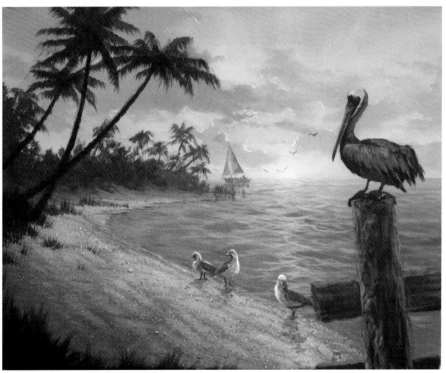

14 Paint the Trees and Underbrush

Mix 1 part Hooker's Green and ¼ part Dioxazine Purple to get a very dark, blackish-green color. Load a no. 4 Dynasty, slightly fan the bristles out and begin streaking in the leaf canopy. Be sure to leave interesting pockets of negative space and overlap the leaves to create good eye flow.

Paint in the underbrush at the base of the tree trunks using the same brush, color mixture and technique. Note that if you pull upward, it will leave the top edge of the brushstrokes softer.

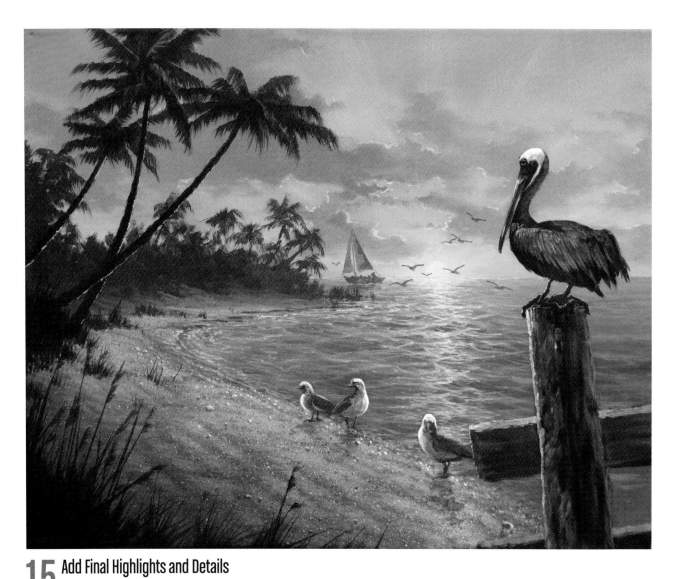

15 Add Final Highlights and Details

You can really put your artistic license to use in this step. To create a brighter sun glow and highlights on the water ripples, mix white with a touch of Cadmium Yellow Light and Cadmium Orange. Use a no. 4 sable round and gentle strokes to paint the bright highlights of the waves all the way down to the shoreline. Next, go along the shoreline and paint in brighter ripples and pebbles. (Don't be afraid to repeat the highlight process more than once if you want brighter results.) Then, add more white to the mixture and make the sun brighter.

Continue using the same brush to add final highlights and details to the birds, then switch to a no. 4 Dynasty for the pier post. Make the light areas brighter and use softer, grayer tones on the shadowed areas to give them a small amount of detail. Remember that these are backlit objects and will not have much detail because they are primarily in shadow. Streak in various grayish tones—just enough to show minor amounts of detail.

Step back and evaluate your work. Then, add additional objects, highlights or details, and tweak any areas that need a technical adjustment. Start by painting taller weeds in the foreground with a no. 4 Dynasty. The sharp chisel edge makes great tall, skinny weeds, but you can use a no. 4 sable script if you prefer. Use the same color mixture for this that you used for the palm leaves and underbrush.

Mix white and Cadmium Yellow Light. With a no. 4 sable round or no. 4 sable script, apply a fine silver lining on the pier post, on palm tree trunks and along the shoreline. Be sure to keep them segmented and not make solid hard outlines. Finally, use a no. 4 sable script and a medium-dark gray tone to paint in the distant flying seagulls.

Paint an Autumn Scene

AUTUMN'S PALETTE

Who doesn't love the sounds, smells and colors of a beautiful cool autumn day? Ever since I was a child, I've anticipated the arrival of autumn each year with much excitement. Activities like raking and burning leaves, hunting, fishing, hiking and camping make it one of my favorite seasons.

As an artist, autumn is all the more special to me because it offers the opportunity to study nature at its finest. The season provides a great "classroom" for learning about the delicate balance of color in a landscape, and understanding complementary color schemes, color balance and color harmony, in addition to values and temperature balance.

Naturally, when you add a graceful animal like a white-tail deer, you have a painting that is not only beautiful but also a real joy to create. The tall grasses, running stream and rugged rocks complete the tranquil, aesthetic scene.

1 Prepare the Canvas and Sketch the Composition

Use a no. 12 bristle flat to apply a warm gray tint to the canvas. Once dry, create a rough sketch of the main components of the landscape, including the main ground contours with soft vine charcoal. Do not spend time on details. You can create a more detailed sketch on a sketch pad to use as occasional reference, if you wish to do so.

Materials

SURFACE
20" × 16" (51cm × 41cm) stretched canvas

ACRYLIC PIGMENTS
Burnt Sienna, Burnt Umber, Cadmium Orange, Cadmium Red Light, Cadmium Yellow Light, Dioxazine Purple, Hooker's Green, Turquoise Deep, Ultramarine Blue

BRUSHES
- 2" (51mm) hake
- nos. 2, 4, 6 and 12 bristle flats
- nos. 2, 4 and 6 Dynasty
- no. 4 sable flat
- no. 4 sable round
- no. 4 sable script

OTHER
- soft vine charcoal
- white Conté pencil
- white gesso

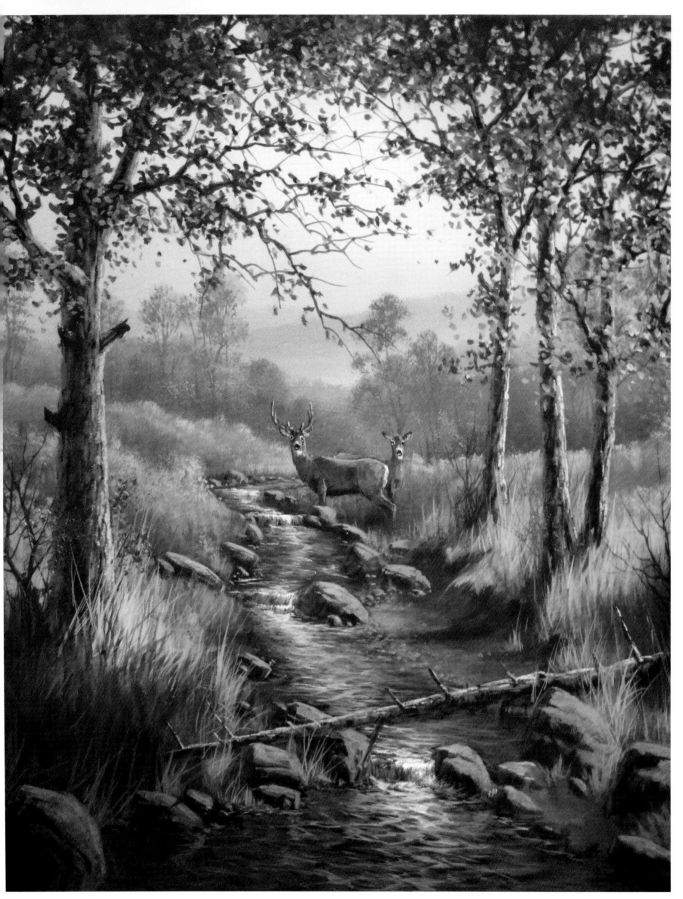

Autumn's Palette
Acrylic on canvas
20" × 16" (51cm × 41cm)

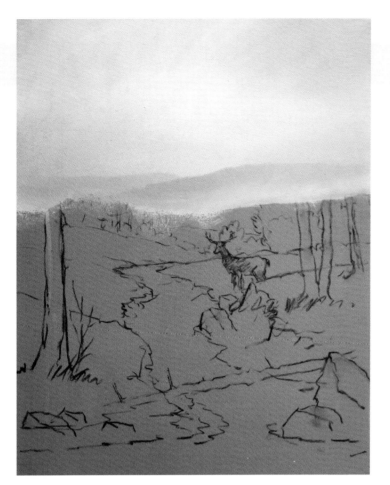

2 Underpaint the Sky and Distant Hills

Apply a liberal coat of gesso over the entire sky with a hake brush. Be sure it is well covered and blended with large crisscross strokes. While the gesso is still wet, add a small amount of Cadmium Red Light across the horizon and blend it upward until it disappears and becomes a soft pink. Rinse your brush, then add a small amount of Ultramarine Blue across the top of the sky. Blend it downward into the pink using large crisscross strokes until you have a softly blended sky.

While the sky is still wet, double-load the hake brush with a touch of Dioxazine Purple and Ultramarine Blue. Paint in the first two layers of distant hills. Make sure you have two value changes and keep the edges very soft.

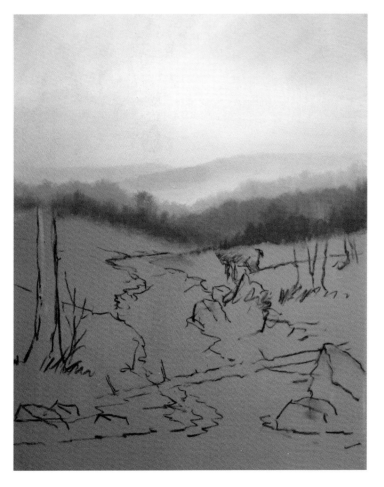

3 Paint the Tree-Covered Hills

You will be using the same technique to paint each row of trees. All you need to do is change the value and color for each layer.

Mix 1 part Ultramarine Blue with touches of Dioxazine Purple and Burnt Sienna. Add just enough white to make it about two values darker than the color of the distant hills. Dab in the first row of trees with a no. 4 bristle flat. Keep the edges soft and irregular.

Add a bit more Burnt Sienna and a touch of Hooker's Green to the mixture to create a warm gray. Dab in the next row of trees. Then, add a touch of Dioxazine Purple to the mixture and dab in the third row of trees. Make sure you leave some irregular pockets of negative space in between the trees.

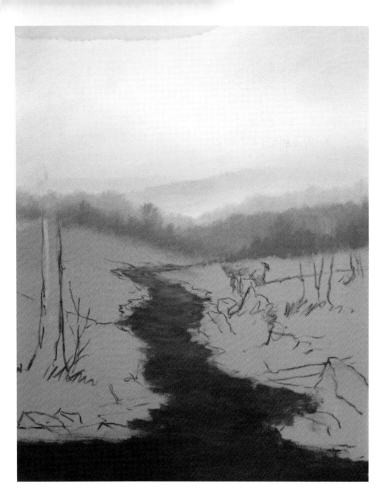

4 Underpaint the Stream

Load a no. 4 bristle flat with Ultramarine Blue along with touches of Turquoise Deep and white. Start at the back and use short, choppy horizontal strokes to begin painting in the stream. As you work your way forward, slowly begin to darken the mixture by adding touches of Dioxazine Purple and Burnt Umber. Keep your brushstrokes parallel—this will help the water appear level. Do not be afraid to leave some brushstrokes showing, which will give the water some movement.

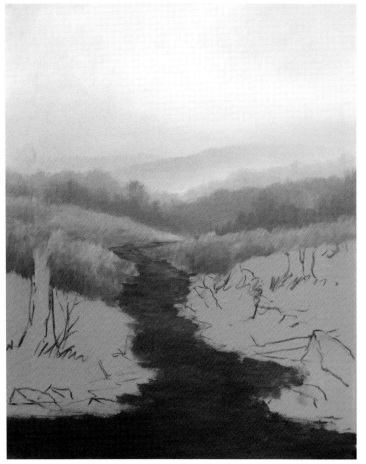

5 Underpaint the Middle-Ground Meadow

Mix Cadmium Orange, Cadmium Yellow Light, Burnt Sienna and Dioxazine Purple. With a no. 6 bristle flat, scrub in lighter values starting at the top of the ridge in the back-left area of the meadow. Use short, choppy, loose vertical strokes to suggest grasses and brush. Work your way to scrubbing in the darker values as you go along. Underpaint the rest of the meadow in the middle ground in the same manner, working from top to bottom and light to dark.

Tip Paint with quick, clean, decisive strokes—and keep them limited. Too many brushstrokes will kill a painting.

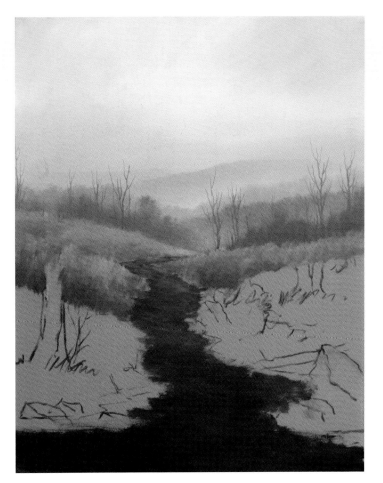

6 Paint the Mist and Distant Tree Trunks

It's time to paint in the mist, which will add great depth and atmosphere to the composition. Create a pale purple-blue color by mixing a touch of Dioxazine Purple with Ultramarine Blue with white. Load a small amount onto the tip of a no. 2 or no. 4 bristle flat, then wipe most of it off. Use small, tight circular strokes with the edge of the brush to drybrush in the mist between the ridges and trees.

Next, create a medium-light gray color by mixing white with Ultramarine Blue, Dioxazine Purple and a touch of Burnt Sienna. Experiment with this mixture until you get the value and hue you need. Thin it to an ink-like consistency and paint in the distant tree trunks with a no. 4 sable script.

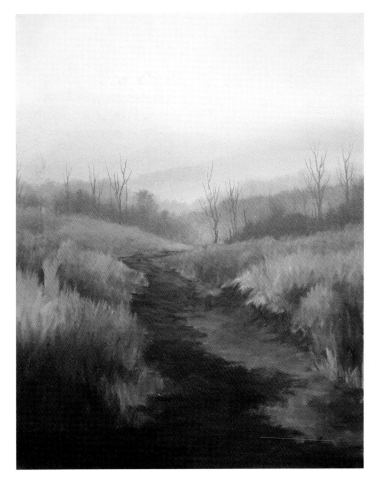

7 Develop the Foreground

Paint the foreground grasses using the same colors, brush and brushstroke techniques you used to paint the meadow area in step 5. The only real difference here is that you will want to make the grass brushstrokes a little taller and looser. Also, use slightly brighter light tones and deeper dark tones.

Mix Burnt Umber with a touch of Dioxazine Purple and white, and paint in the upper, darker area of the eroded riverbank with a no. 4 bristle flat. For the lower, lighter area, add more white and a touch of Cadmium Orange. Blend the two areas together until you have the look of a gradated eroded bank.

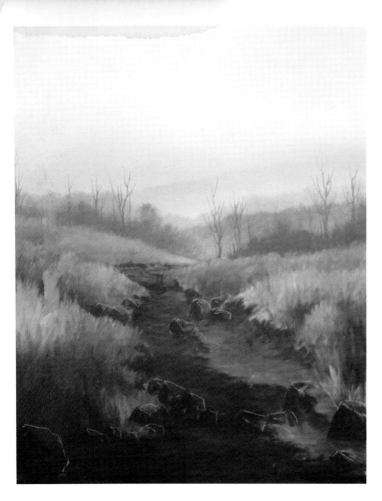

8 Underpaint the Rock Formations

Lightly sketch in the major formations with a white Conté pencil. (I left a few of the pencil lines showing here, so you can see how they were laid out.) Create a medium-dark mixture from 1 part Ultramarine Blue, ½ part Burnt Sienna and a touch of Dioxazine Purple and white. With a no. 4 or no. 6 bristle flat, underpaint the shadow side of all the rocks. Use very loose brushstrokes.

9 Begin Highlighting the Rocks

Create a soft, warm medium-gray by mixing white with a touch of Cadmium Orange and Ultramarine Blue. Make sure it is not too white or too bright. This is only the first phase of the highlighting process, so you want to start with a medium-tone gray and build on it from there. Load a very small amount onto a no. 4 bristle flat. Paint in the first rock formation highlights with quick, loose brushstrokes.

10 Develop the Trees

Mix 1 part Cadmium Yellow Light, ¼ part Dioxazine Purple and a touch of Cadmium Orange with white to create a rich medium-gold color. Use a no. 2 or no. 4 bristle flat to carefully dab leaves onto all the tree trunks. Be sure to create interesting pockets of negative space for an open, lacy effect.

Take the same color mixture and add a touch of Cadmium Yellow Light. Carefully highlight the top right side of the trees.

11 Begin Highlighting the Water

It's time to paint the first highlights on the water. There will be a couple more layers of highlights after this one, so be careful not to get too bright at this point. Take a small amount of white and add just a touch of Ultramarine Blue and Turquoise Deep. Thin it to a creamy consistency. Load a small amount across the tip of a no. 2 Dynasty and hold the brush at a horizontal angle to the painting. Begin applying highlights to the background water with irregular, elliptical strokes. As you come to the small waterfalls, add a bit more white to the mix and use dry-brush comma brushstrokes to create the falls. Switch to a no. 4 or no. 6 Dynasty and continue on with the same strokes all the way into the foreground.

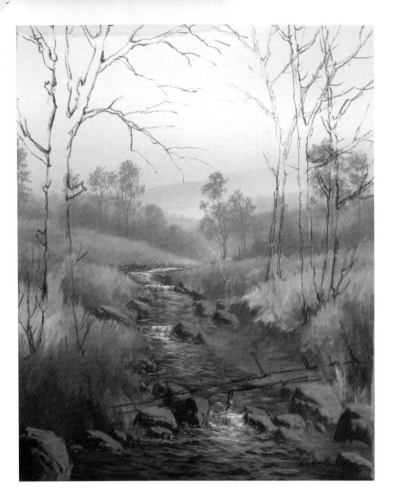

12 Re-sketch the Main Components

Use soft vine charcoal to re-sketch the large trees on both sides of the creek, the fallen log and maybe another rock or two. Be absolutely sure you are happy with the placement and proportion of the tree trunks before proceeding.

Don't worry about sketching in the deer at this time. That will be done in the last couple of steps.

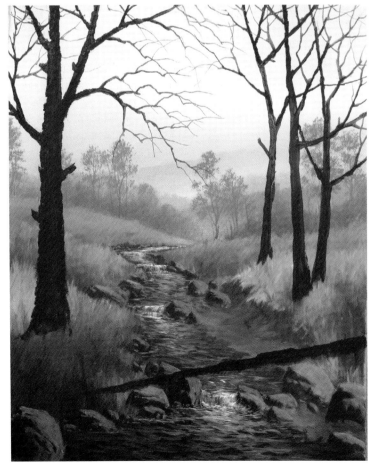

13 Underpaint the Tree Trunks

Create a creamy dark mixture of 1 part Burnt Umber, 1 part Ultramarine Blue and about ½ part Dioxazine Purple. With any small-sized Dynasty you feel comfortable using, begin blocking in the tree trunks and larger limbs. Thin the mixture to an ink-like consistency and finish the smaller limbs with a no. 4 sable script. You can add additional limbs as needed in the last step.

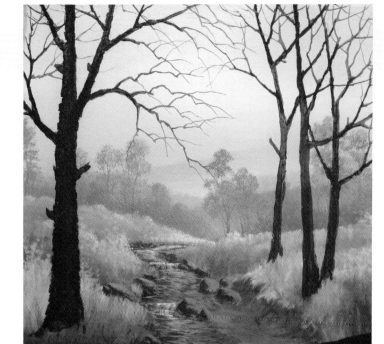

14 Highlight the Leaves and Grasses

Create rich, creamy color mixtures in various tones of yellows, oranges, reds and golds. Gently fan out the tip of a no. 2 or no. 4 bristle flat and load it with small amounts of your color mixtures. Very lightly dab highlights on the top right side of each of the clumps of leaves.

Move down to the grassy meadows and use a variety of colors and strokes to build up the grasses and brush. Be careful not to over-highlight. Make sure you leave some pockets from the darker areas of the original under-painting. This will create interesting ground contours.

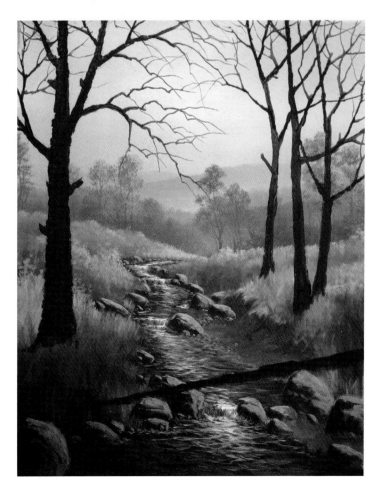

15 Continue Highlighting the Rocks and Water

Apply the next layer of highlights to the rocks and water, beginning with the rocks. Create a soft, warm highlight color by mixing white with a touch of Cadmium Orange. (You could use Cadmium Red Light instead if you prefer for the color to be more on the pink side.) Thin it to a creamy consistency and load a small amount onto a no. 4 Dynasty. Carefully paint highlights onto the rocks. Pay special attention so as not to lose all of the underpainting.

Next, mix white with a touch of Ultramarine Blue. Load a small amount onto the tip of a no. 2 Dynasty and paint the next layer of highlights on the water.

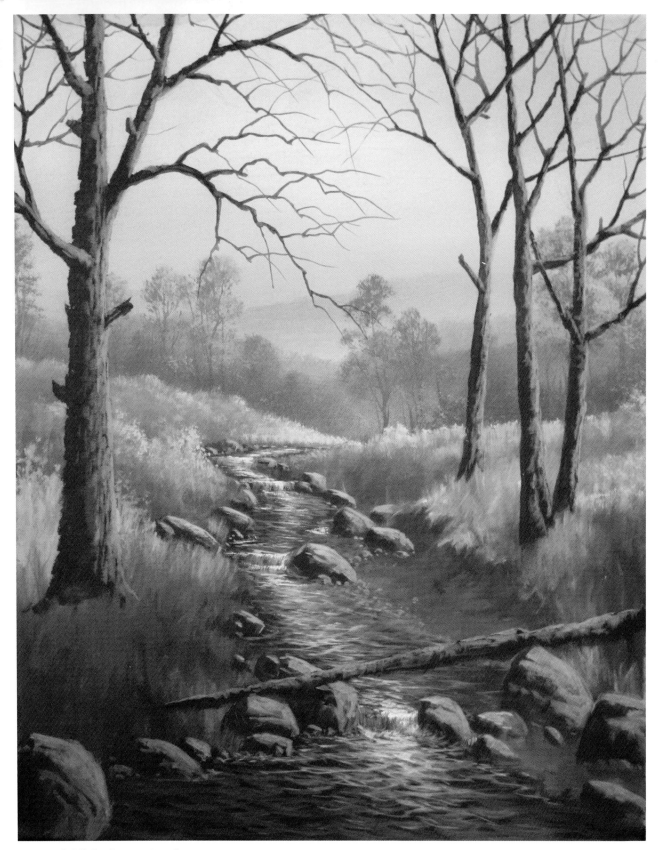

16 Highlight the Tree Trunks

Create a soft, warm color similar to the mixture you used to highlight the rocks. Load a small amount onto the tip of a no. 4 or no. 6 Dynasty. Hold the brush at a vertical angle to the painting and move up the tree on the sunlight side using short, choppy, connected strokes. Pull the brush sideways as you move upward, and only go about halfway across the tree until the highlight fades into the dark shadow. You will add brighter highlights along with reflected highlights in the final step.

17 Develop the Foreground

Paint in some tall bright grasses and brush, as well as some darker, shadowed grasses. This will seat the trees and rocks and finish out the edge of the stream. Thin down some bright colors of your choosing to a creamy consistency. Load a no. 4 Dynasty and position the chisel edge vertically to the canvas. Begin pulling up the grasses at the base of the trees, near the rocks and along the stream.

Mix equal parts Cadmium Red Light and Dioxazine Purple to get a deep rich burgundy color. Load a no. 4 or no. 6 bristle flat and block in the concentrated areas of the canopy of leaves for the foreground trees. Switch to a no. 4 sable flat or a no. 2 Dynasty and begin painting all of the individual leaves. This process does take a while, so just understand that you will need to be patient if you want to create a nice canopy with interesting pockets of negative space. Once you have finished the darkest leaves, begin adding the lighter tones of yellows, golds and oranges.

18 Underpaint the Deer and Continue Adding Details

Re-sketch the deer with soft vine charcoal. Mix 1 part Ultramarine Blue, ¼ part Burnt Sienna and just enough white to get a medium warm gray tone. Underpaint the deer with a no. 4 sable flat and a no. 4 sable round. Ensure that the value is correct for that area of the painting.

Thin the gray mixture to an ink-like consistency. Paint in the saplings at the base of the large trees and the broken limbs on the log with a no. 4 sable script.

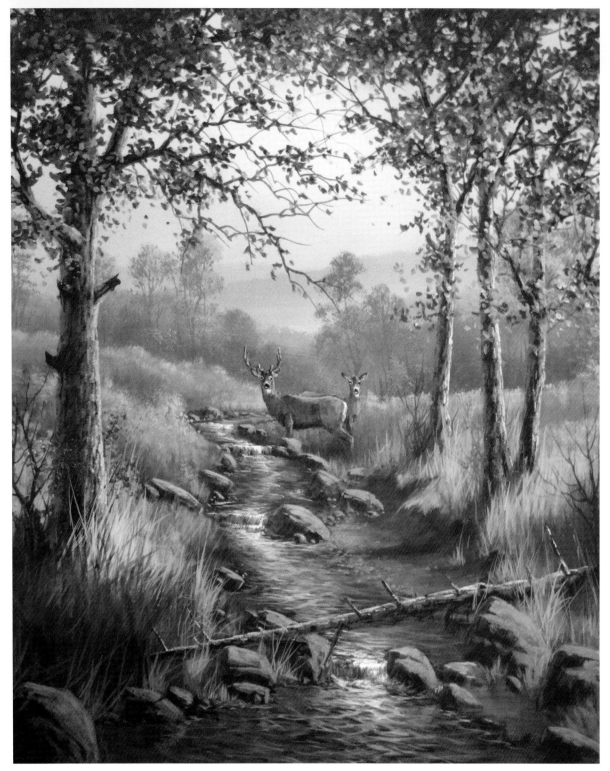

19 Make Adjustments and Add Final Highlights and Details

Use whatever small brushes you are most comfortable with for this step. Highlight the deer with the same warm gray color you used to underpaint them. Gradually lighten the mixture with white and a touch of Cadmium Orange. Continue applying highlights to the deer while allowing the underpainting to come through in the shadowed areas to give them their form.

Next, paint reflected highlights on the shadow side of the tree trunks, rocks and log with a mixture of Dioxazine Purple,

Ultramarine Blue and a little white. Drybrush a small amount of this color along the shadowed side and gently feather it toward the center of the shadowed area. This will help create roundness and softness.

Finally, scatter a few warm autumn tones across the water to soften and warm it up. Finish by adding more leaves, taller weeds and minor highlights and colors here and there.

Paint a Winter Scene

COLORS OF WINTER

If you want to do a painting that will make you smile from start to finish, this is the one! The winter atmosphere with blowing snow, rich complementary colors, strong contrast of light and shadow and balance of warm and cool colors make this a true artistic adventure. It also presents the challenge of creating a successful composition with numerous overlapping shapes.

Do not let these birds scare you. Just look at it as an opportunity to learn the correct process for underpainting and detailing a variety of birds that will increase your technical knowledge and help you to become a more well-balanced artist.

Materials

SURFACE
16" × 20" (41cm × 51cm) stretched canvas

ACRYLIC PIGMENTS
Burnt Sienna, Burnt Umber, Cadmium Orange, Cadmium Red Light, Cadmium Yellow Light, Dioxazine Purple, Hooker's Green, Naphthol Crimson Turquoise Deep, Ultramarine Blue

BRUSHES
- 2" (51mm) hake
- nos. 2 and 4 bristle flats
- nos. 2, 4 and 6 Dynasty
- no. 4 sable flat
- no. 4 sable round

OTHER
- medium or firm toothbrush
- soft vine charcoal
- white Conté pencil
- white gesso

1 Prepare the Canvas with a Mottled Background

Apply a liberal coat of gesso to the canvas with a hake brush. While the gesso is still wet, begin adding Ultramarine Blue, Dioxazine Purple, small amounts of Burnt Sienna and even a little Turquoise Deep. Blend all of the colors together until you have a soft, cool, mottled background. Be careful not to over-blend or you will lose the various values and colors.

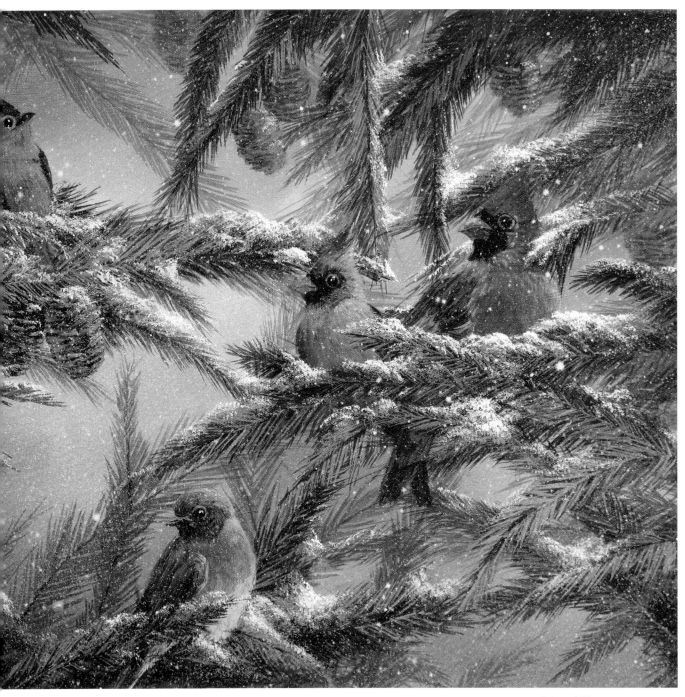

Colors of Winter
Acrylic on canvas
16" × 20" (41cm × 51cm)

2 Block In the Pine Boughs and Needles

Mix Hooker's Green with a touch of Dioxazine Purple and Turquoise Deep, plus a bit of white to slightly lighten it. Use a no. 4 or no. 6 Dynasty to stroke in very fine lines to suggest pine boughs and needles. It's OK if the color and value change from bough to bough—this will add more depth and interest to the background. Use lots of overlap to create interesting pockets of negative space. You will add more pine boughs and needles as the painting progresses.

3 Sketch the Birds and Pine Cones

Use soft vine charcoal or white Conté pencil to make light, rough sketches of the location, size and type of birds you want to have in your painting. Take your time to arrange the birds so you create good eye flow and overlap and, as usual, interesting pockets of negative space. (The birds I chose are male and female cardinals, a tufted titmouse and an eastern bluebird.) You will also want to sketch in some pine cones to help balance out the composition.

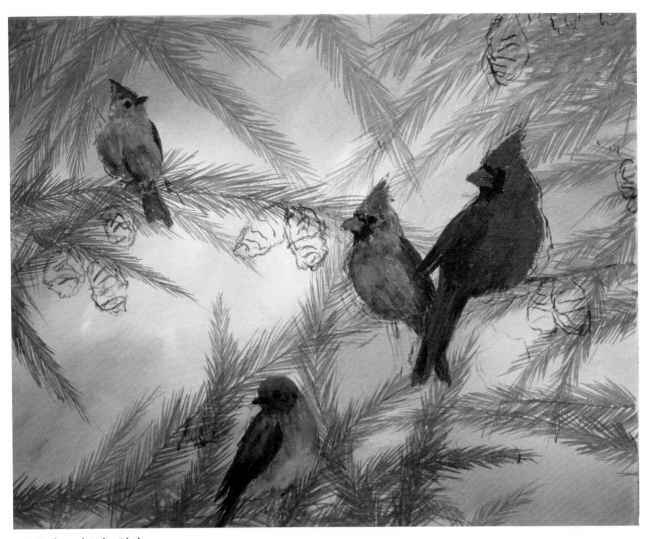

4 Underpaint the Birds

Underpaint each bird with a dark undertone. I recommend using a no. 4 sable flat or round for the smaller areas and a no. 2 bristle flat for the larger areas.

Underpaint the entire male cardinal (right), including the beak, with a mixture of 1 part Cadmium Red Light and ¼ part Dioxazine Purple. Then, add a bit more Dioxazine Purple to darken the mix, and add another layer onto the wing. Create a black mixture for the very dark areas, such as the eyes, beak and underside of the wings, from equal parts Ultramarine Blue and Burnt Umber. You will use this mixture for the dark areas on all the birds.

For the female cardinal, mix Burnt Umber with a touch of Cadmium Yellow Light and white for underpainting the main body.

This should be a medium-dark value. Use the Cadmium Red Light and Dioxazine Purple mixture for the wing, and the black mixture for the very dark areas.

For the bluebird, use Ultramarine Blue for the head and wing and the black mixture for the beak, eye and other dark areas. Mix Burnt Sienna with a little Burnt Umber and white for the breast area. Mix a soft gray tone for the lower area of the body.

Underpaint the titmouse with mottled brownish grays. Mix Burnt Sienna with a touch of Ultramarine Blue and mottle various tones and values throughout the body. Finish with the black mixture in the dark areas.

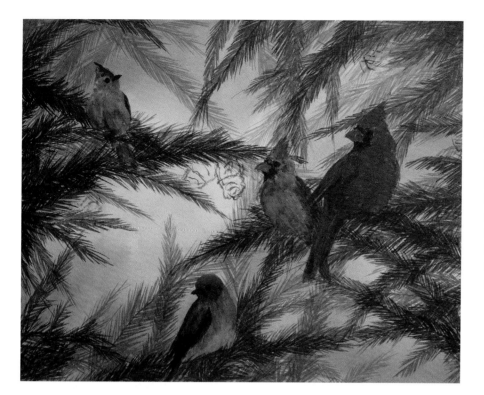

5 Add More Pine Boughs

Paint additional pine boughs tucked in and around the birds, intermingled with the boughs that you painted earlier. You will need to make these boughs darker than the original boughs to create depth. This will also make the birds look nestled in the mass of boughs. Mix 1 part Hooker's Green with about ¼ part Dioxazine Purple. Thin it to a creamy consistency and use a no. 4 Dynasty and the same technique you applied in step 2 to paint in the next layer of pine boughs. You will add even more boughs in later steps.

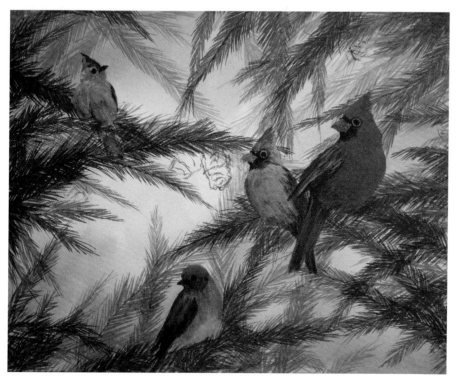

6 Highlight and Detail the Cardinals

For the first phase of highlighting and detailing the cardinals, bring the color up by about two values and make anatomical adjustments to the overall shape of the birds (i.e., head, eyes, beak, torso, tail and main wings). For the male cardinal, mix 1 part Cadmium Red Light with ¼ part Naphthol Crimson and just a touch of white to make it more opaque. Drybrush this color in all the red areas with a no. 4 Dynasty. Use your black mixture for the dark areas. Use any small brush that works for the female cardinal. Paint her body with a mixture of Burnt Umber and a touch of Cadmium Yellow Light and white to create a soft butterscotch color. Use the black mixture for dark areas. Create a dirty orange tone for the beak by mixing Cadmium Orange with a touch of Ultramarine Blue.

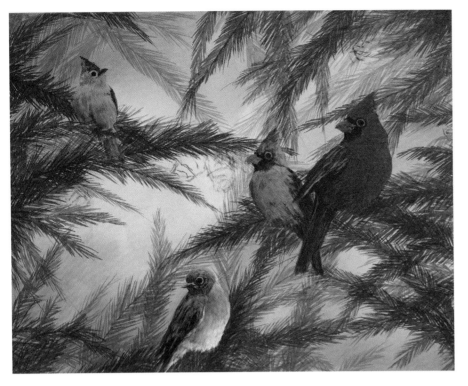

7 Highlight the Bluebird and Titmouse

The titmouse does not need much highlighting or detail because you do not want it to stand out too much. Take the mottled brownish gray mixture you used in step 4 and add a little white plus a touch of Cadmium Orange. Gently drybrush highlights on the titmouse that are about two values lighter than the original underpainting. Be sure to leave some of the underpainting color showing through to give the body dimensional form. Adjust the other body parts so they are anatomically correct.

For the bluebird highlights, take each underpainting color and add small amounts of white to bring up the colors by about two values. You will add final highlights in the last steps.

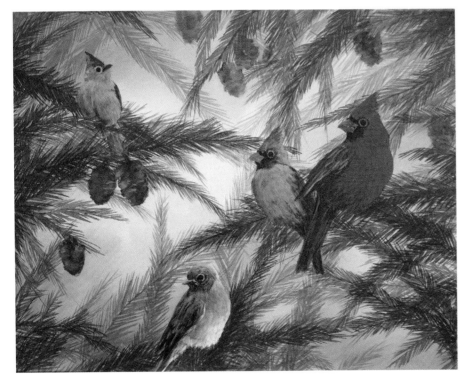

8 Underpaint the Pine Cones

At this stage, you may find that you need to re-arrange the pine cones from their original locations. Once you are happy with the pine cone placements, mix Burnt Umber and Ultramarine Blue with a touch of white to create a rich, warm medium-dark brown. Use a no. 4 bristle flat to underpaint the pine cones. Dab them in with fairly thick paint to create a little texture. Add small amounts of white as you go along to create a slightly mottled effect.

s WCOLORS OF WINTER

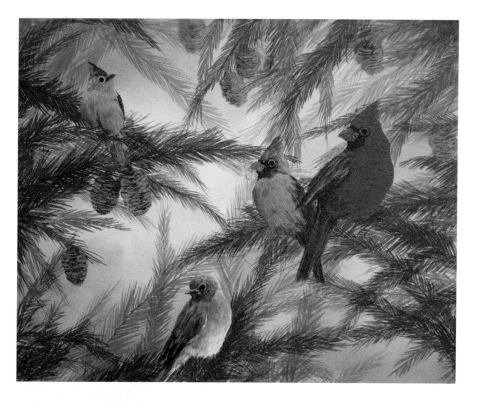

9 Detail the Pine Cones
Mix Burnt Sienna with a touch of Cadmium Yellow Light and white to create a rich butterscotch color. Load the paint mixture across the tip of a no. 2 Dynasty and dab straight in with a light tap, carefully creating the design of pine cones. Make sure you don't over-highlight. This is only the form highlight to show the basic design of the pine cones. You will add final highlights in the last steps.

10 Highlight the Birds
Highlight the birds with a no. 4 sable round. Mix Cadmium Red Light with a touch of Cadmium Orange and white. Highlight the male cardinal on the upper breast area, the top knot and along the right side of his body. Add a touch more white for the loose feathers around the wing and tail. Highlight the beak with a bit of Cadmium Orange. Do not be afraid to make some of the darks darker to help with contrast.

The female cardinal does not need as much highlighting. Use the butterscotch mixture from the previous step on her breast area. Add a touch of white and highlight the shoulder and back of her head. Highlight the beak with a touch of Cadmium Orange.

For the bluebird, mix Ultramarine Blue with a touch of white to highlight the head and wing. Add white to the rust color on the upper breast area and carefully brighten the right side of the body. Use white with a touch of Cadmium Orange for the lower body.

Spend as much time as you need to clean up the eyes, beaks or any other anatomical issues. Note, you may also need to add a little highlight on the three pine cones just below the titmouse.

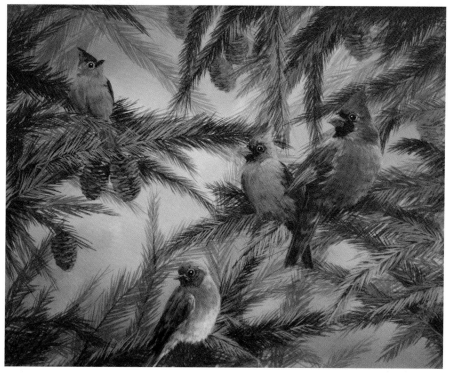

136

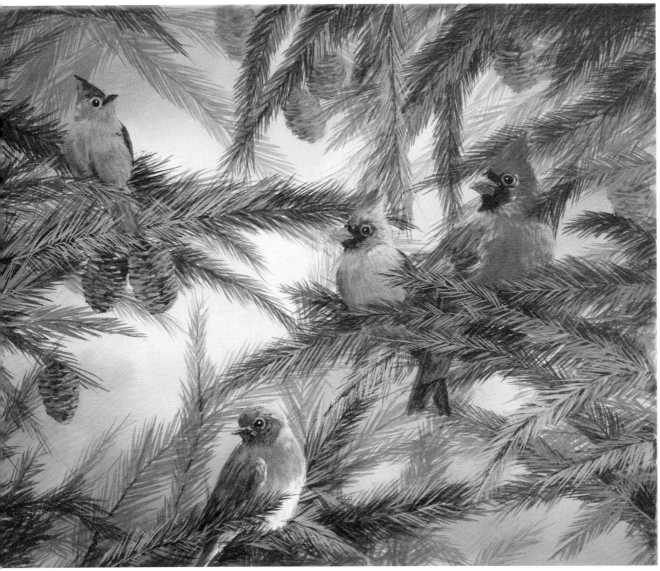

11 Add More Pine Boughs

Go back to the dark mixture of Hooker's Green and Dioxazine Purple that you used in step 5. Use a no. 4 Dynasty to paint in the pine boughs at the base of each bird. Be sure to let the boughs overlap with the birds to give the birds the appearance of being nestled into the boughs.

Next, highlight the boughs with the same tones you used in the previous step. (When you add snow on the pine boughs later, it will finish the process of seating the birds.)

This would be a great place to spend a little more time re-working the pine boughs by highlighting some of them, adding additional pine cones and making some darker and some lighter. Since this

is a fairly busy collection of limbs, the best way to tell if you have a good arrangement is to study your painting from about 6 feet (2m) away to see if there is good eye flow. Also, check to see if any boughs lead you off the canvas. Correct any issues you notice.

Mix a highlight color of equal parts Hooker's Green and white with a touch of Turquoise Deep. Use a no. 4 Dynasty to highlight some of the pine boughs. You do not need to highlight every bough, just enough to add contrast, better form and light. You will add more boughs after final highlights have been added to the birds.

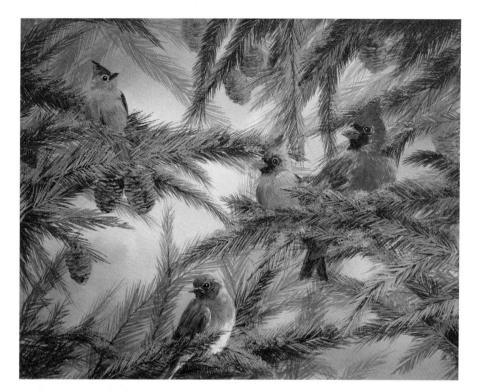

12 Paint the Snow

It's time to apply the first layer of snow, which will be the shadow. Mix 1 part Ultramarine Blue, ¼ part Dioxazine Purple, ¼ part white and a very small amount of Burnt Sienna to desaturate the mixture. Use a no. 2 or 4 bristle flat to dab in color where the snow would drift or pile up in little pockets—places where limbs overlap and at the bases of the birds. It is not necessary to put snow on every bough, but focus on the ones that will hold the viewer's attention closer to the birds.

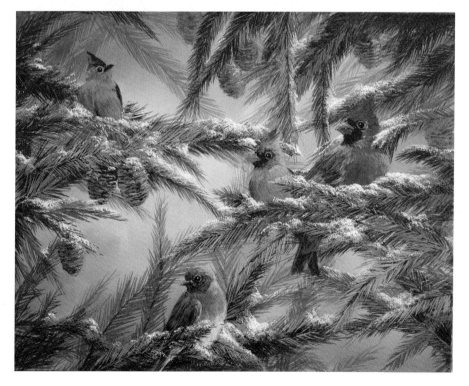

13 Add the Brightest Highlights

Mix white with a slight touch of Cadmium Orange. Load the very tip of a no. 2 bristle flat and begin dabbing the brightest highlights on the shadowed snow. It is important to remember that you only want to cap the top of the snow. By leaving some of the shadows, the snow drifts will appear more dimensional.

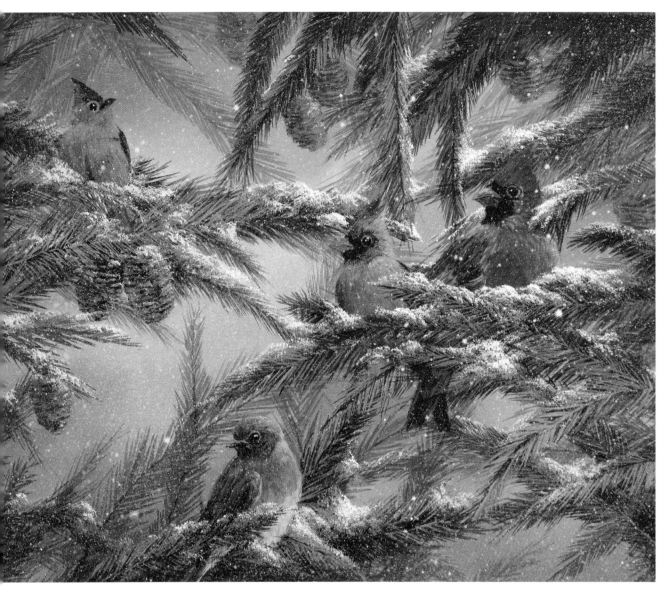
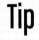

14 Add Snow Flakes and Final Details

This last part is optional. Some artists may prefer to leave the painting as it is at this stage. However, this final step can create a little more atmosphere and interest in your composition.

Mix white with a touch of Cadmium Orange and thin it to an ink-like consistency. Use a hake brush to lightly coat the entire canvas with water. While the canvas is still wet, load the mixture onto a medium or firm toothbrush, flick the brush with your forefinger, and let the paint splatters land on the canvas. They will soften as they bleed into the wet surface. If you want more crisp snow flakes, wait until the painting is dry and then splatter the flakes on the dry surface. The splatters will not bleed and will stay brighter.

Tip Do not try to paint above your ability. Gradually work your way up to the next level with practice, practice, practice!

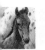

Index

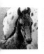

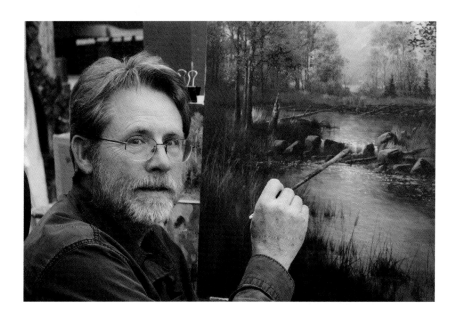

About the Author

Jerry Yarnell was born in Tulsa, Oklahoma, in 1953. A recipient of two scholarships from the Philbrook Museum of Art in Tulsa, Jerry has always had a great passion for nature and has made it a major thematic focus in his paintings. He has been rewarded for his dedication with numerous awards, art shows and gallery exhibits across the country.

His awards include the prestigious Easel Award from the Governor's Classic Western Art Show in Albuquerque, New Mexico; acceptance in the top one hundred artists represented in the national Art for the Parks competition; an exhibition of work in the Leigh Yawkey Woodson Birds in Art show and partici-pation in a premier showing of work by Oil Painters of America at the Prince Gallery in Chicago. Some of Jerry's personal fine art pieces can be found in his Oklahoma Studio as well as his online gallery at www.josephyarnell.com. Collectors can be added to his collector-notification list by emailing the Yarnell Studio & School of Fine Art, LLC at jerry@yarnellschool.com.

Jerry has another unique talent that makes him stand out from the ordinary: He has an intense desire to share his painting ability with others. For years, he has held successful painting workshops and seminars for hundreds of people. Jerry's love for teaching also keeps him very busy holding workshops and giving private lessons in his Yarnell Studio and School of Fine Art.

Jerry is the author of sixteen painting instruction books, and his unique style can be viewed on his popular PBS television series, *Paint This With Jerry Yarnell®*, which airs worldwide and is the no. 1 art show of its kind in Canada. Jerry and his wife, Donna, have expanded their world into a thriving Yarnell family community with a following of more than 60,000 students.

The Yarnell Studio & School of Fine Art is home to Donna and Jerry's Yarnell School Online (YSO), which houses the massive new collection of Jerry's instructional materials, making them available via streaming video to thousands of YSO student-members worldwide. Their successful certification programs continue to regularly produce Yarnell Certified Artists™ as well as Yarnell Certified Instructors™, who share and teach Yarnell tried-and-true techniques around the nation.

For more information about the Yarnell Studio & School of Fine Art, LLC., and to order books, instructional videos and painting supplies, contact:

Yarnell Studio & School of Fine Art, LLC.
P.O. Box 1120, Skiatook, OK 74070
877-681-4ART (4278)
Email: jerry@yarnellschool.com
Instructional website: YarnellSchool.com
Online art gallery: JosephYarnell.com

ACKNOWLEDGMENTS

Ms. Donna and I want to thank the thousands of students and viewers of our *Paint This with Jerry Yarnell* ™ television show, who are also members of Yarnell School Online, regulars at my studio workshops and collectors of my personal art pieces. We want to thank Tech Know World, Anello Productions and Universal Media for their strong support through the years. We thank PBS, OETA, RSU TV, NRB, Create TV and all the networks that air our TV shows. We want to acknowledge Merrilou, who works alongside Donna and me at our studio daily. And we certainly want to recognize the North Light Books staff for their continued belief in my abilities.

DEDICATION

First and foremost, I give God all the praise and glory for my success. He blessed me with the gift of painting and the ability to share the gift with people around the world. He has blessed me with a new life after a very close brush with death. I am here today and able to share all of this with each of you because we have a kind, loving and gracious God. Thank you, God, for all you have done.

The next dedication goes to my beautiful bride, Ms. Donna. God brought her into my life several years after my wife Joan passed away. Donna has not only made me a better artist and teacher, she has catapulted the Yarnell Studio & School of Fine Art, LLC into successful proven-growth areas that I once had only daydreamed of having. She is my soul-mate, my best friend and my dedicated partner. With my God and Ms. Donna at my side, nothing is impossible.

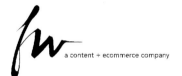

a content + ecommerce company

Other fine North Light books are available from your favorite bookstore, art supply store or online supplier. Visit our website at fwmedia.com.

22 21 20 19 5 4 3 2

Distributed in the U.K. and Europe
by F&W Media International LTD
Pynes Hill Court, Pynes Hill, Rydon Lane
Exeter, EX2 5AZ, UK
Tel: (+44) 1392 797680
Email: enquiries@fwmedia.com

ISBN 13: 978-1-4403-5021-4

Editor: Christina Richards
Designer: Clare Finney
Production Editor: Jennifer Zellner
Production Coordinator: Debbie Thomas

METRIC CONVERSION CHART

To convert	to	multiply by
Inches	Centimeters	2.54
Centimeters	Inches	0.4
Feet	Centimeters	30.5
Centimeters	Feet	0.03
Yards	Meters	0.9
Meters	Yards	1.1

Ideas. Instruction. Inspiration.

Receive FREE downloadable bonus materials when you sign up for our free newsletter at artistsnetwork.com/Newsletter_Thanks.

Artists network
ARTISTSNETWORK.COM

These and other fine North Light products are available at your favorite art & craft retailer, bookstore or online supplier. Visit our websites at artistsnetwork.com and artistsnetwork.tv.

Find the latest issues of *Artists Magazine* on newsstands, or visit artistsnetwork.com.

Get your art in print!

Visit artistsnetwork.com/splashwatercolor for up-to-date information on Splash and other North Light competitions.

Follow North Light Books for the latest news, free wallpapers, free demos and chances to win FREE BOOKS!